COTTINGHAM
THROUGH TIME

Peter McClure, Katrin McClure
& Tony Grundy

With Dorothy Catterick & Rachel Waters

AMBERLEY PUBLISHING

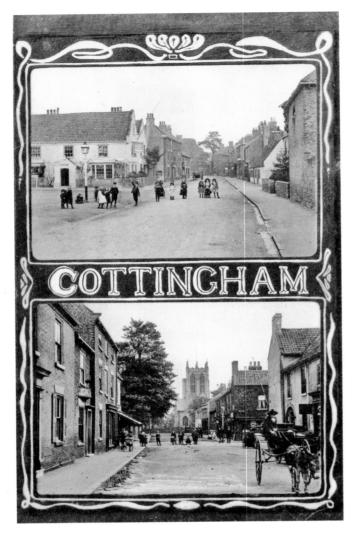

**Cottingham Postcard,
Posted 19 October 1912**
This Edwardian postcard by William Knaggs, a Hallgate barber and newsagent, shows King Street above, with Market Green and the Duke of Cumberland on the left and the stables of Kingtree House (now demolished) on the near right. Hallgate is below, with a view of St Mary's fourteenth- to fifteenth-century central tower. The front and back covers of this book show similar views of King Street (*c.* 1898) and Hallgate (*c.* 1910), with a horse-drawn milk cart, but the postcard producers are unknown.

First published 2013

Amberley Publishing
The Hill, Stroud, Gloucestershire, GL5 4EP
www.amberley-books.com

Copyright © Peter McClure, Katrin McClure
& Tony Grundy, 2013

The right of Peter McClure, Katrin McClure & Tony Grundy to
be identified as the Authors of this work has been asserted in
accordance with the Copyrights, Designs and Patents Act 1988.

ISBN 978 1 4456 1409 0 (print)
ISBN 978 1 4456 1423 6 (ebook)

British Library Cataloguing in Publication Data.
A catalogue record for this book is available from the
British Library.

Typesetting by Amberley Publishing.
Printed in Great Britain.

Introduction

Cottingham likes to be known as the largest village in England. In medieval times it stretched 6 miles from the River Hull westwards to the Wolds at Raywell, and nearly 4 miles southwards from Beverley to Hull: over 9,000 acres of arable, woodland, meadows, pastures and marshland. It included the hamlets of Dunswell, Newton, Eppleworth, Newland, and Hull Bank. In the late medieval period it was the East Riding's third most populous and prosperous town, after Beverley and Hull. Between 1872 and 1935 it lost over 6,000 acres, mostly to an expanding Hull, but its population has increased from around 2,000 in 1800 to over 17,000 today.

Cottingham, 'the homestead of Cotta's people', was founded by Anglo-Saxons, perhaps in the sixth century, on a gravel spread at the end of a dry glacial valley. This offered excellent drainage, good agricultural land and plenty of water from wells dug into the chalk aquifer below. There are three streams: Mill Beck and its tributary Creyke Beck run south and were manmade, to drive two medieval watermills, the naturally east-flowing but intermittent Broad Lane Beck depends on field run-off and the unpredictable flowing of Keldgate springs.

Words like *keld* 'spring', *gate* 'street' and *beck* 'stream' were introduced by Danish Vikings, who settled in Yorkshire in the tenth century. The Danes were followed in 1066 by Normans. In the late 1100s the de Stutevilles (from Étoutteville in Normandy) built a fortified hall or castle at the west end of Hallgate ('the street to the Hall') and obtained licences to hold markets, of which Market Green is a visible reminder. The large, beautiful church of St Mary is mainly fourteenth century, reflecting the wealth of later lords the Wakes and the Plantagenets. The manor was subsequently split into four, and one of the replacement manor houses still stands on the castle mound. Late sixteenth century and timber-framed, it is Cottingham's oldest domestic house, followed by Southwood Hall, a superb brick dwelling of around 1660.

After the Reformation in the mid-1500s, Protestantism took hold in Cottingham and Nonconformist worship subsequently flourished here. John Wesley visited Cottingham several times, and in 1790 his friend

Thomas Thompson financed Cottingham's first Wesleyan chapel, in Northgate. The Zion chapel and the later, larger Methodist chapel, both in Hallgate, are part of that legacy.

In 1771 and 1793, most of Cottingham's common lands were enclosed. The village now belonged chiefly to arable and dairy farmers, market gardeners (using Hull's animal and human waste to fertilise fields of vegetables, flowers and soft fruit for the Hull market), and rich Hull businessmen, who built themselves large 'gentry' houses in Cottingham. The coming of the railway in 1846 tied Cottingham closer to Hull. Extra housing was built for a growing population of commuters, and in Hallgate and King Street some existing houses, many eighteenth century in origin, were converted into shops. The station and the stationmaster's house survive as does the line itself, despite numerous threats of closure since the 1960s.

During the twentieth century, many farms, market gardens and gentry houses were lost to new housing. Since the 1950s it has been home to thousands of students at Hull University, which saved many gentry houses by converting them to student accommodation. The university also built a striking complex of student halls at the Lawns (Northgate) in the 1960s. Castle Hill Hospital and Swift Group (caravans) have become major employers. There is always pressure to build more houses, but Cottingham villagers are determined to keep green fields between themselves and Hull and to preserve the varied and much loved character of their historic streetscape.

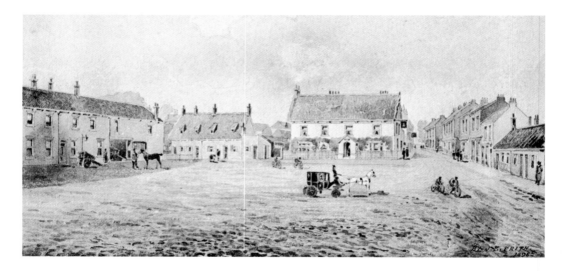

Market Green and King Street, Looking North, 1896
The earliest image of Market Green is this watercolour by J. E. Frith. He was a coach painter of King Street, hence his trademark miniature horse-drawn cab. The Green is shown as rough, open ground, partly bordered with housing. King Street's road surface is stone and slurry and the four 'safety' bicycles depicted would have a bumpy, dusty ride.

**Market Green Looking
North, 1925, and
South-West, 2011**

The 1925 view shows the Duke
of Cumberland on the Green's
north side. In the south-east
corner is a row of houses
and the Reading Room, now
demolished. Below them are
King Street Rooms, also now
gone. To its left are the grounds
of Elm Tree House, now
occupied by blocks of flats.
The 2011 view, from St Mary's
tower, shows Elm Tree House
and flats at the back, and in
the foreground the Duke of
Cumberland's two white gable
ends. It is Cottingham Day, and
games are being played on the
tarmacked Green.

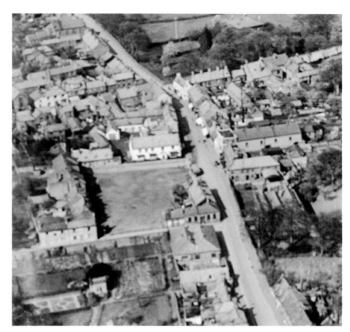

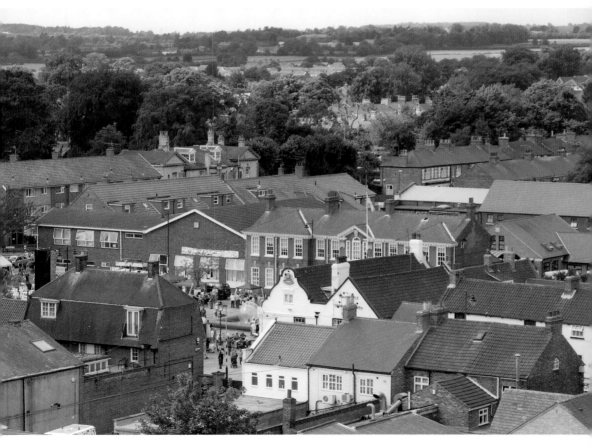

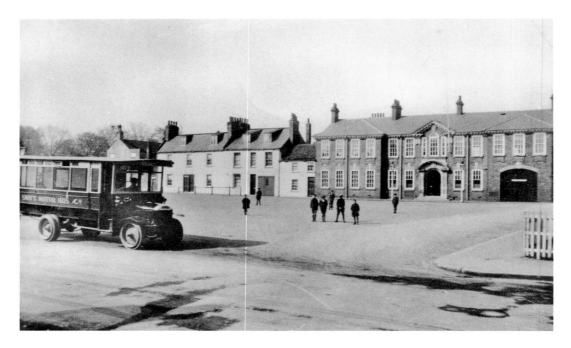

Market Green, *c.* 1923: Civic Centre and Transport Hub

The Council Offices (1910) recall a time when Cottingham had its own Urban District Council (1894–1935), looking after its roads, housing, health, and firefighting services. Since 1935, the building has been adapted to other uses; the fire station (far right) is now the public toilets. After 1918, solid-tyred motor buses replaced horse-bus services between Cottingham and Hull. In 2013, with street lights and bus shelter, the Green is still the village's central bus stop.

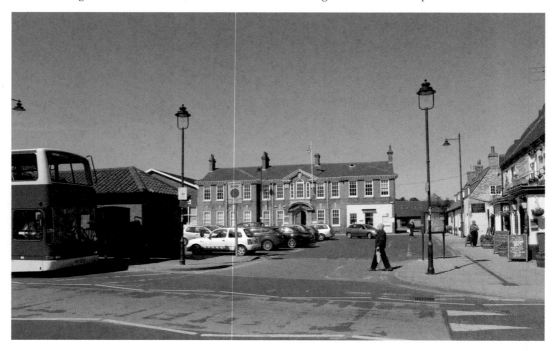

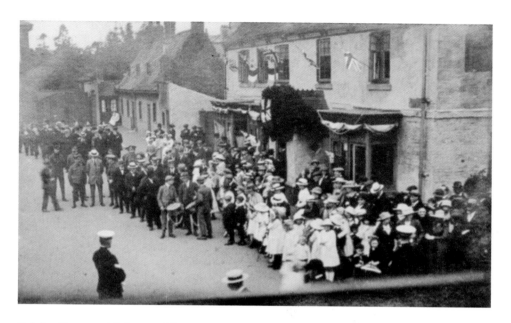

Celebrations and Fairs, 1918/2011

Crowds celebrate Armistice Day in 1918 outside the Duke of Cumberland, a late seventeenth-century coaching inn. The steep-roofed eighteenth-century cottages beyond are now owned and partly occupied by the parish council. Since 2002, the Green has been the main focus of Cottingham Day (first Saturday of July), with food, fair rides, games and music. A revival of the nineteenth-century Cottingham Club Feast, it was inaugurated by the parish council to celebrate the Queen's Golden Jubilee.

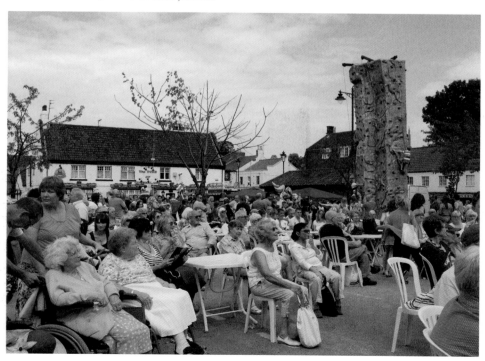

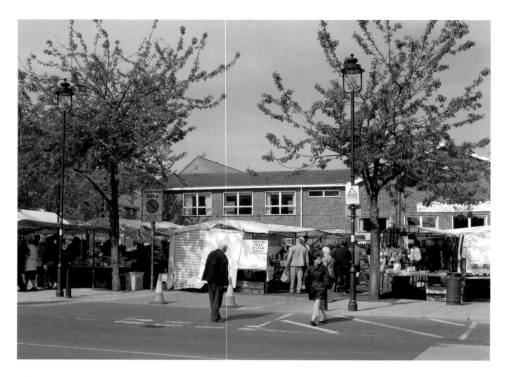

Thursday Market, 2013, and Meeting Place, 1910

Cottingham has had the right to hold markets and fairs since around 1200. The present site was called 'Marketstead Green' in 1601. The market lapsed in the nineteenth century but was revived in 1985. In the lower photograph, the Green is the starting point for an outing of the Free Gardeners' Friendly Society, whose members grew produce for the Hull market. The houses at the back went in 1964–65 to build the Civic Hall and those fronting King Street (left) went in 1967 for road widening.

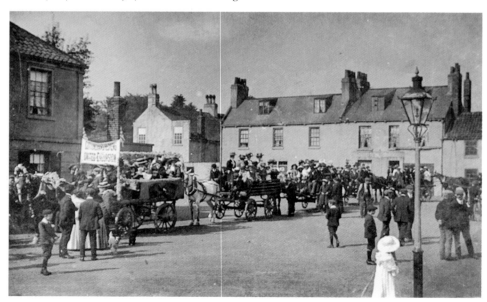

A Finkle Street Flit, 1965

Building the Civic Hall coincided with demolishing the house on the corner of the Green and Finkle Street (No. 24). Its last occupant, Mrs Stephenson, is seen here moving house (flitting). The adjacent houses on the Green itself have already been pulled down. The bollards mark the edge of the Green as a municipal car park. No. 24 and the Finkle Street houses next door were replaced by Jad's Court, a late 1960s terrace of shops and apartments.

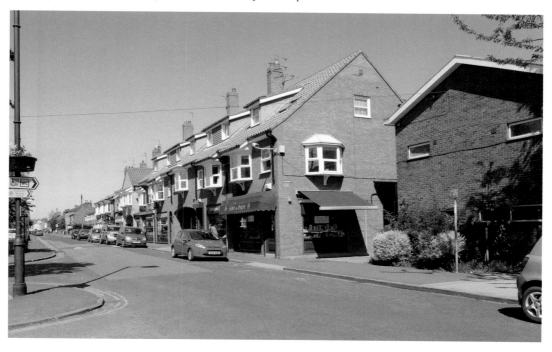

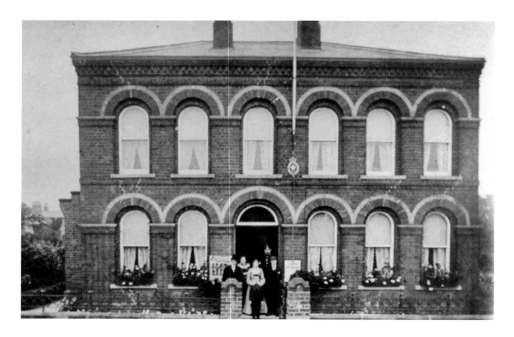

Finkle Street Police Station, *c.* **1910**

Built in 1878, this was the local lock-up (two cells, charge room and general office) and the family home of the sergeant. The sergeant had five police officers under him. Note the police insignia between the bedroom windows and the recruitment poster (for 'His Majesty's Footguards') to the left of the family. After the formation of Humberside Police Force in 1974, the station became offices for the Humberside After-Care and Probation Service. It is now private flats.

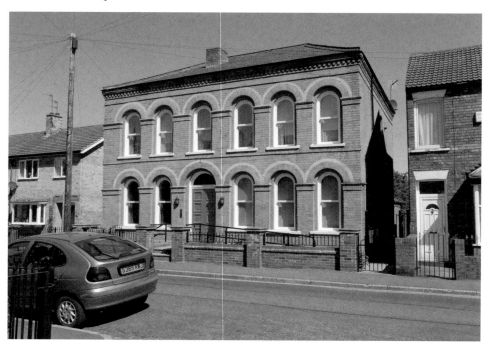

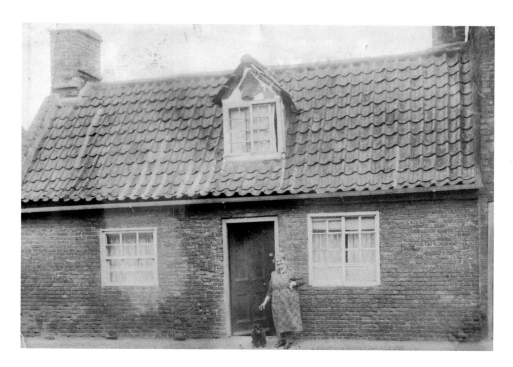

From Cottage to Court

Alice Dandy stands outside No. 138 Finkle Street (north side) in the 1920s/30s. It is a typical eighteenth-century Cottingham brick and pantile cottage, with outbuildings and a large garden designed for self-sufficiency – a pump for supplying household water, an outside toilet, a carpenter's workshop, fruit trees, soft fruit, vegetables, pig sties and a chicken run. It was demolished in the 1990s, but the bungalow that replaced it soon suffered the same fate when Regent's Court, a close of fourteen dwellings, was built in its grounds.

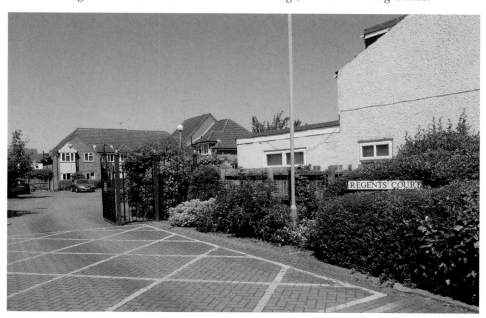

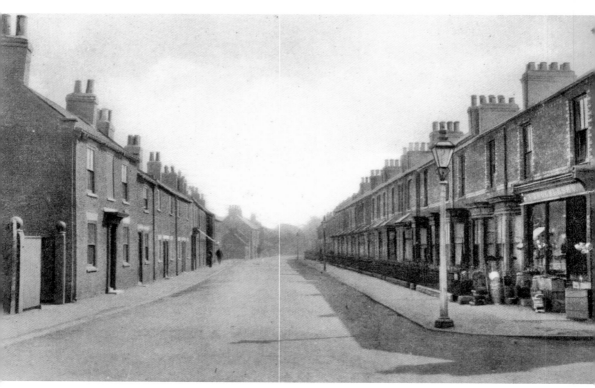

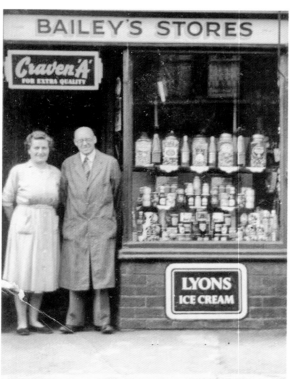

Open All Hours, 1930s/1955
The south side of Finkle Street (far right) has Edwardian houses by William and Harry Whiting. At the west end is one of Arthur Brocklesby's grocery stores. It sold general provisions, and errand boys delivered orders to customers' homes. After the Second World War, ice cream was sold through a side window. Everyone knew Brock's shop! The awning on the other side of the road belongs to another store, Stainton's, which became Bailey's after the war. Ted and Kath Bailey are pictured in their doorway. These 'live-in' shops in residential streets were once essential to daily life, but most have reverted to ordinary houses.

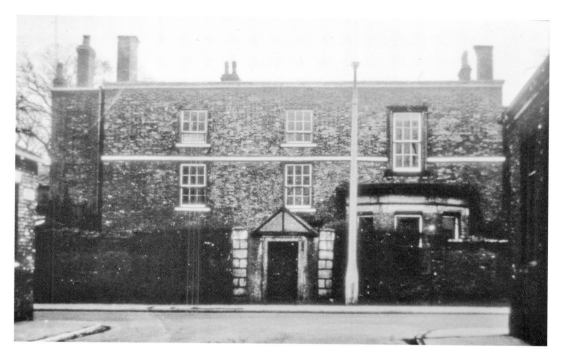

Kingtree House, 1959

Opposite the junction of Finkle Street with King Street stood Kingtree House, built before 1769 for Samuel Watson, a Hull sugar merchant. Stretching to Hallgate, Beck Bank and Newgate, the estate included pleasure grounds, a kitchen garden and a meadow. It was later sold off for house building, including Kingtree Avenue in the 1930s. The house was demolished in 1959–60 to build the parade of shops in the lower photograph. A Cottingham traveller's racing cart trots past.

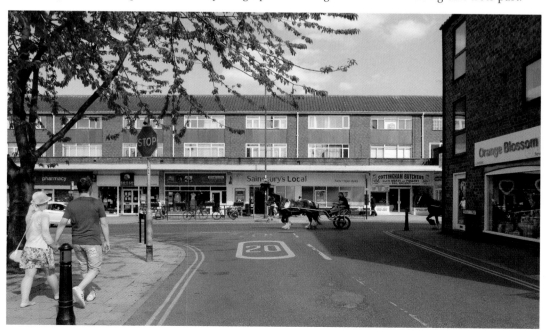

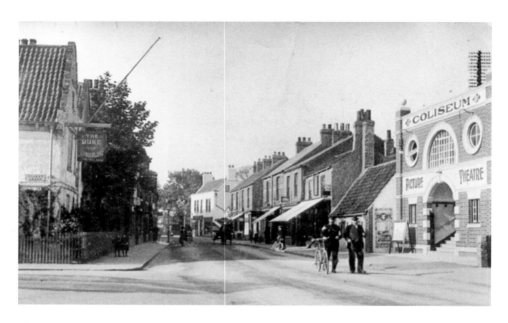

The Cinema, King Street Looking North, *c.* 1922

The 'Cosy Coliseum' was built in 1913 and showed silent films. In 1920 it was used as a pearl button factory, but in 1922 it reverted to the 'Coliseum' cinema. When it finally closed in 1929, it was redesigned as a house and shop for the British Gas Light Co., and until the 1980s it was the North Eastern Gas showrooms. After that it became Hutchinson's furnishers, then 'A-Z' household stores, and now Fulton's frozen food stores.

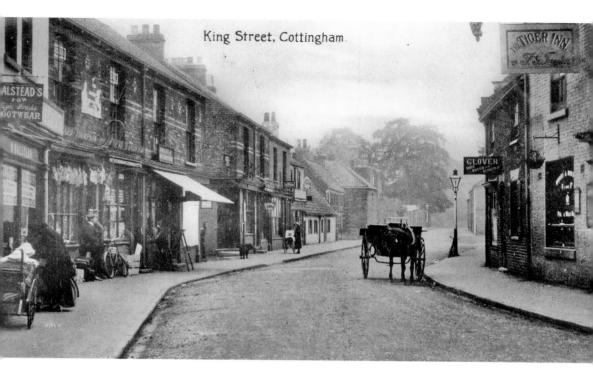

King Street, Cottingham.

King Street Looking South, *c.* 1910/1950s

Harry Halstead from Lancaster (left signboard) and Charles Glover from Norton by Malton (right) had opened their boot shops here by 1911. The Tiger Inn (far right) is late eighteenth century. Round the corner was the Angel, which became the Memorial Club for ex-Servicemen in 1920, the National Provincial Bank in 1950 (lower photograph) and the Halifax Estate Agency in 1970 (now gone). Clifford's newsagent's is now Turnbull's. The twin gables belong to the Duke of Cumberland. The EYMS bus's roof was shaped to pass under Beverley's North Bar.

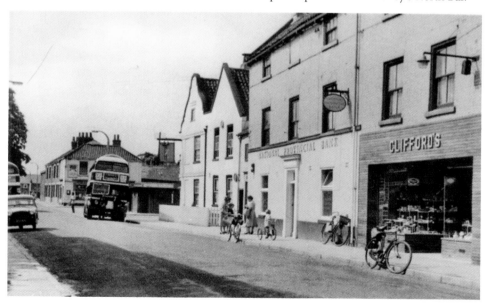

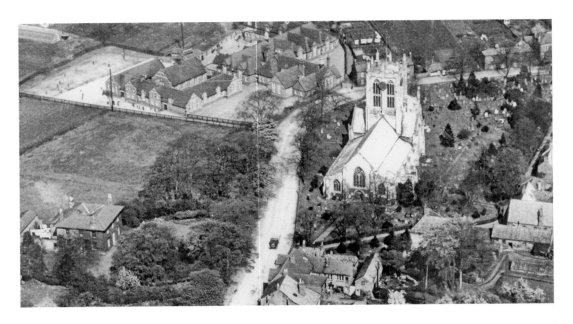

Church and School, 1925/2011

Hallgate east, formerly Kirkgate, curves round St Mary's, one of the largest and most beautiful medieval churches for miles around. The Board School (built 1892–1913, with boys, girls, and infants separately governed) is top left. Bottom left is the rectory (1847), demolished and replaced by a new rectory across the road in 1976. In 2008, Hallgate Infants and Juniors amalgamated. The new primary school (lower picture) and Cottingham Pre-school are now on the old rectory site.

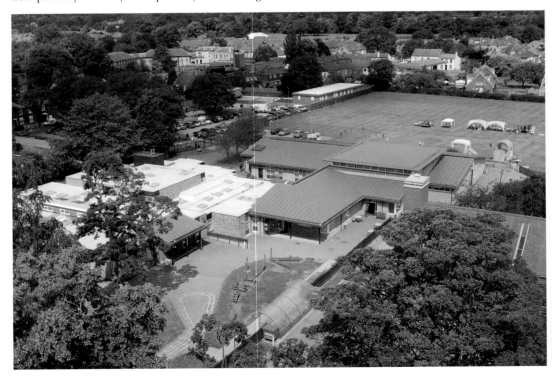

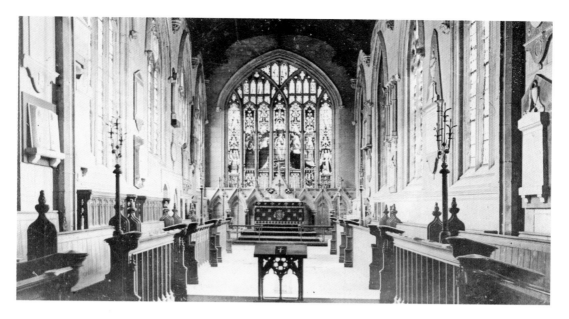

St Mary's Church, *c.* 1904, and Choir Practice, 2013
The elegant chancel and east window were built in 1374 for the rector, Nicholas of Louth, whose memorial brass can still be seen. This wealthy cleric, one of Edward III's senior officials, owed his benefice to Edward the Black Prince, then lord of the manor. In 1844–45 the Revd Charles Overton restored the church, and in 1875 had the east window reglazed. The Victorian arched reredos below it, displaying the Lord's Prayer, the Creed and the Ten Commandments, was later removed (possibly in the 1930s).

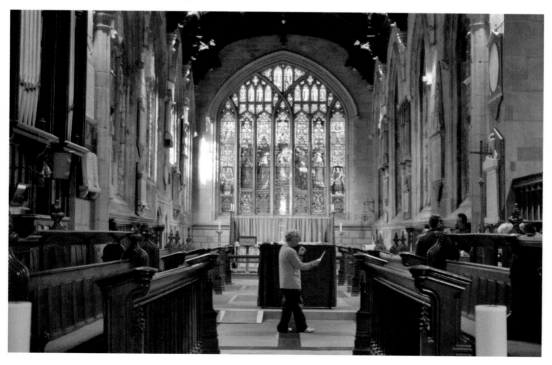

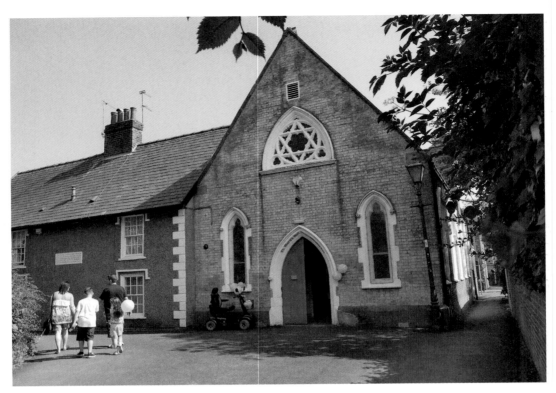

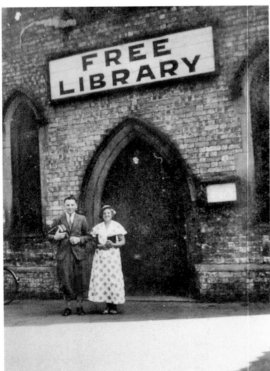

St Mary's Church Hall, Alias Arlington Hall, 2013/1928

Immediately to the south of the church, on the right in the 1925 aerial view (p. 16), is Church Walk. Arlington Hall (1850) was used originally for vestry meetings, and now for a variety of church and village events. From 1928 to 1955 it housed Cottingham's first free public library. On the right is Church Lane, running from Newgate Street to the church through the former pleasure grounds of Kingtree House. It is one of Cottingham's many 'snickets', the footpaths that provide shortcuts from one street to another. To the left of the hall is Church House, built in 1729 as a workhouse, now a private residence with a nineteenth-century frontage.

The Ground sᶜᵗʰⁱˢ Houſe stands upon was the Gift of Richard Burton Gen: to the Uſe of the Poor of Cottingham for Ever: purchal·d of W: G: Weſtby Eſqʳ for 40ˡ in the Year 1728: And built at the Expence of the Pariſhoners in the Year 1729. ～

Church House and the Mark Kirby Free School

The plaque on Church House records its origins. Next to it is the Mark Kirby Room, an 1861 replacement of the original Free School. Probably founded in 1666 by John Wardle, it was endowed in 1712 by Mark Kirby 'for the teaching of ten poor children of parents not of the ability to pay for their learning'. The school was the first of several educational establishments that clustered around the church. It closed in 1878, but the Mark Kirby Trust continues to give grants towards the education of Cottingham children. The last house in Church Walk is Church View, built in 1819 for the schoolmaster, and later much extended.

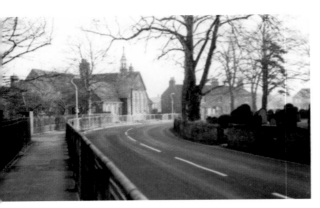
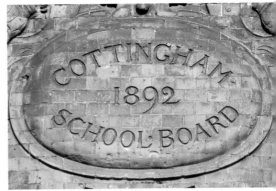

The Board School, Hallgate, 1986/1921

Founded in 1892, the Board School provided education from infancy to teens, until in 1955 the County Secondary School opened on Harland Way. The 1921 photograph shows a class of infants. When the old rectory was demolished in the 1970s, a new Hallgate Infants School was built there, leaving the Board School as Hallgate Junior School. When the juniors were amalgamated with the infants (see p. 16), the council sold the Board School buildings to a private faith school.

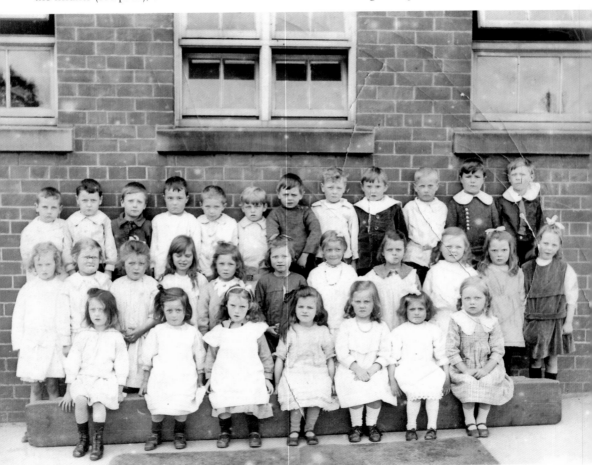

Adult Education in Cottingham, 2003/2007

For many years the Cottingham Institute of Further Education provided adult education in prefabricated buildings on the Hallgate School site. In the top photograph the Scout Hall, now demolished, is just visible behind the end of the prefab. The current purpose-built Adult Education Centre replaced the prefabs on land between the new primary and old board schools in 2005, ensuring the continuation of education provision on this site for all ages from preschool to retirement.

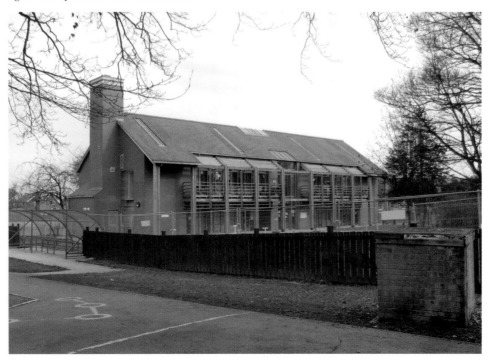

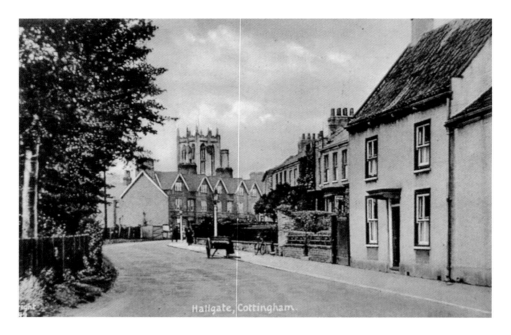

Hallgate from Fussey's Corner, *c.* 1935

East of the church, Hallgate winds round towards Beck Bank and the station. The original nineteenth-century terraces remain much as they were, but Beckbridge Farm (right) has been demolished, replaced by a garden wall. From 1912, Fusseys ran their horse buses from here. Early in the twentieth century there were two private schools, one in Arlington Villas (visible in front of the church) and another opposite. The gate next to the Villas led to Harrison's racehorse stables (p. 28). The semi-detached houses (left) were built in the 1930s when the Kingtree estate and the racehorse paddock were sold.

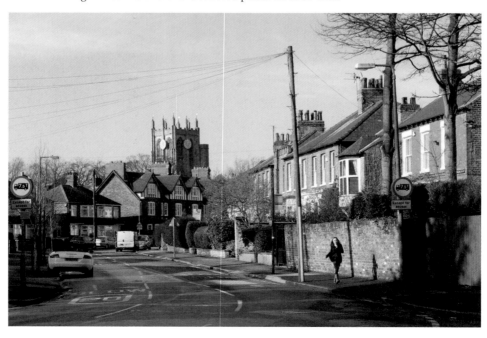

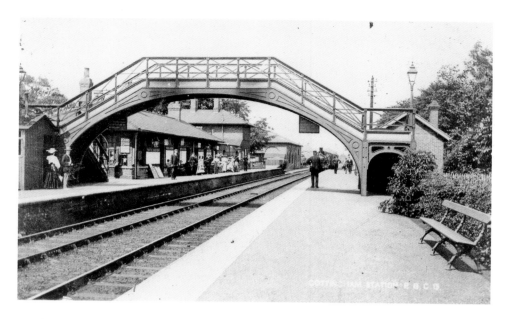

Cottingham Station, *c.* 1908

The station opened in 1846, offering direct travel to Hull, Beverley, Bridlington and York. The Hallgate terraces (p. 22) were built soon after. Passengers were important, especially commuters to Hull and holidaymakers to the seaside, but for over a century the main business was freight, offloading coal, coke, grain, livestock, newspapers, stone, tar, and Hull's human and animal dung at Cottingham goods yard, and taking Cottingham's wonderfully fertilised market garden produce to Hull. At that time there were ten station staff; now there are none.

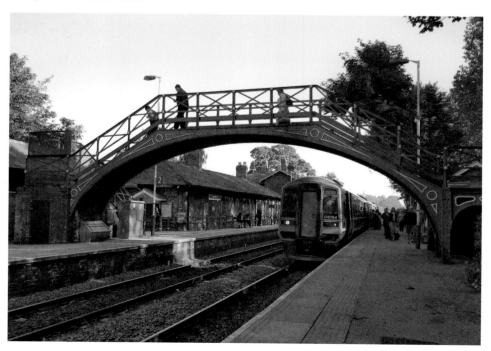

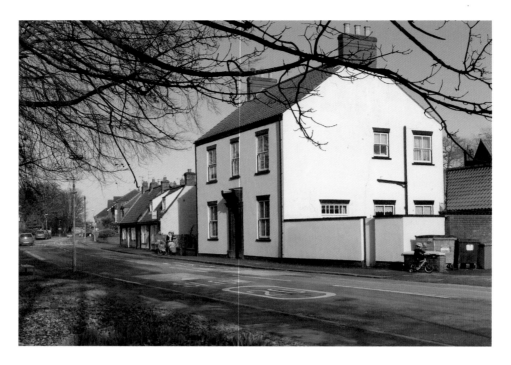

Beck Bank from Newgate Street, 2013/1920s
Hallgate crosses Mill Beck and turns south to Newgate Street and Thwaite Street via Beck Bank. Access to the beck through the railings was for watering horses and tightening wheel rims. The eighteenth-century cottages on the right are now much altered. The houses on the left of the 2013 photograph are from the 1930s, and were reached by little bridges, but in 1966 this part of the beck was culverted to take all the surface water and sewage. Its inability to cope with the downpour on 25 June 2007 was one cause of the disastrous flooding in Cottingham that day.

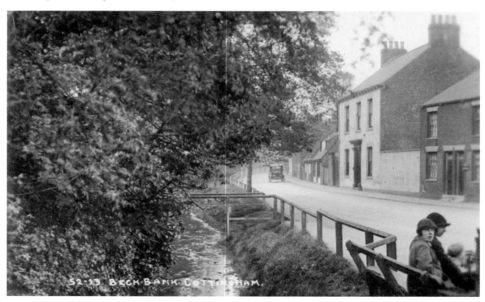

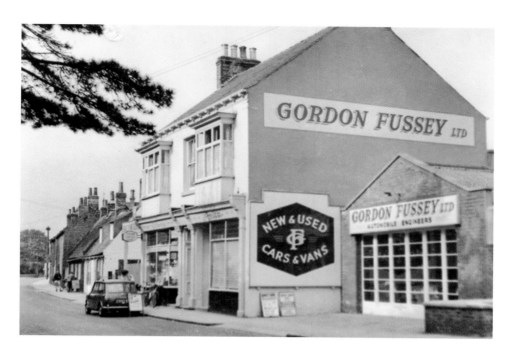

A Beck Bank Family, Early 1960s/1980s

In the early 1900s, the Fussey family ran first horse and then motor bus services between Cottingham and Hull. From 1927 they ran a taxi service in Beck Bank and in the 1930s a garage and a car and motorcycle dealership. The business continued until 1989. The house (*c.* 1869) has seen changes to its frontage, but is now restored to its original appearance (p. 24). In the 1950s, the houses to its right were demolished to build the new Railway Inn (p. 30).

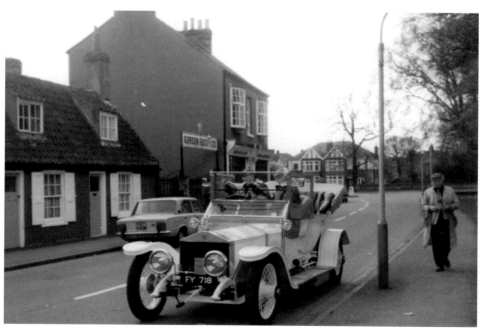

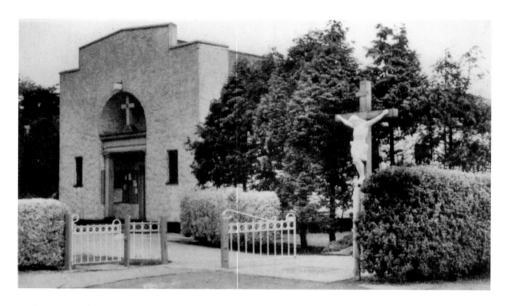

Holy Cross Church, Carrington Avenue, 1930s

The church was built in 1929 for Roman Catholics, who had previously worshipped in the conservatory of 'Cherry Garth' in Beck Bank. Its dedication imitates that of Haltemprice Priory, which claimed to possess a fragment of the holy cross. In the 1980s the church was extended sideways, with the worshippers seated in a semicircle around the altar, now situated in the body of the church. In 2004 an extension known as the 'Garden Room' was added onto the western elevation.

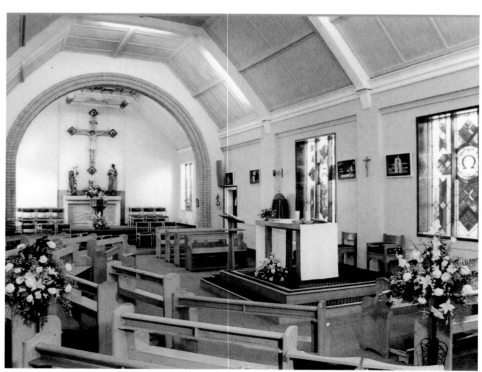

Haltemprice Priory, 1948/1989
Priory Road, off Newgate Street, is named after Haltemprice Priory, founded in 1325–26 by Thomas Wake, Lord of Cottingham. He started building it at the east end of Northgate, but the land's ownership was disputed, so he moved it to the site of a hamlet called Newton, two miles south of the village. In 1536 the priory was suppressed along with other monasteries by Henry VIII. The aerial view, pointing west, shows farm buildings at the end of the priory's moated site. The original farmhouse, built in 1584, reused some of the priory's brick and stone, including the moulded brick doorway and the carved shield of arms above it, which can be seen in the photograph. Though Grade II* listed and lived in until the 1970s, the house is now a vandalised shell, but its current owner plans restoration.

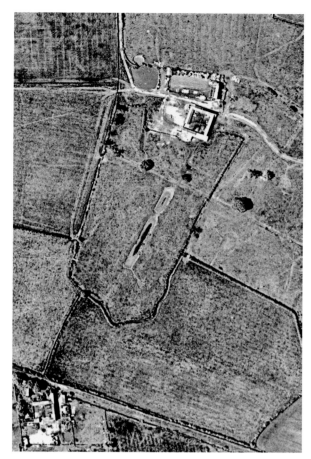

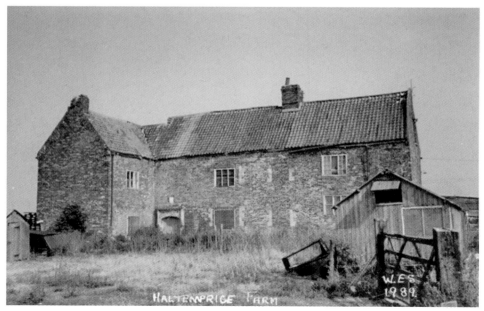

HALTEMPRICE FARM

W.E.S. 1989

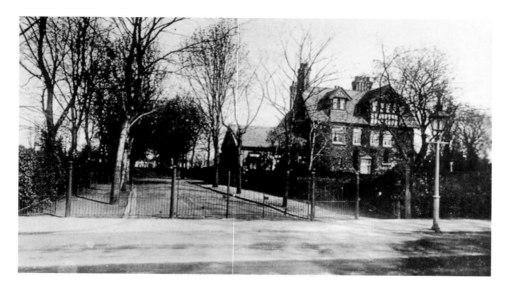

Kingtree Avenue and Shardeloes

'The Avenue' (pictured *c.* 1910) was the driveway to J. S. Harrison's 'Merry Hampton Stud Farm', named after the horse he bred here that won him the 1887 Derby. The farm stretched from Newgate to Hallgate, where the stud groom lived in Arlington Villas. From around 1933 these former Kingtree House grounds were developed for housing, hence the renaming as 'Kingtree Avenue'. 'Shardeloes' was built around 1889. There was local dismay when this rare example of Alfred Gelder's domestic architecture was demolished in 2002–03 to build a block of retirement flats (Shardeloes Court).

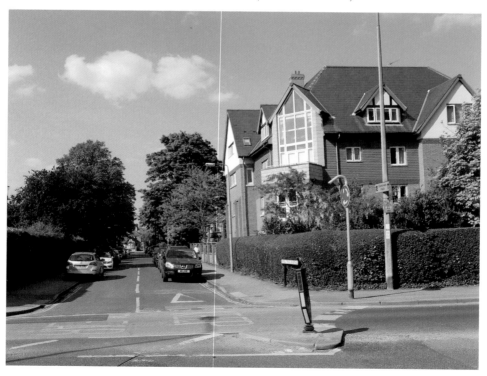

Snuff Mill House, *c.* 1904/1978

South of Beck Bank is Snuff Mill Lane. The laden carts belong to Paley and Donkin, who bought Snuff Mill to weave bagging for the oil seed crushing industry in Hull. Originally called South Mill, it was probably the later of two medieval corn mills on Mill Beck. The North Mill stood on Mill Beck Lane (see p. 42). Snuff Mill was demolished in the 1930s, and the beck and the mill leet were culverted in 1961 to form part of the Cottingham branch sewer. Only Snuff Mill House remains, built around 1760 for William Travis, a Hull tobacco and snuff merchant. In the 1790s Travis built a grander residence, Cottingham Hall, facing Thwaite Street, which was demolished in 1935 to make way for the housing in the aerial photograph.

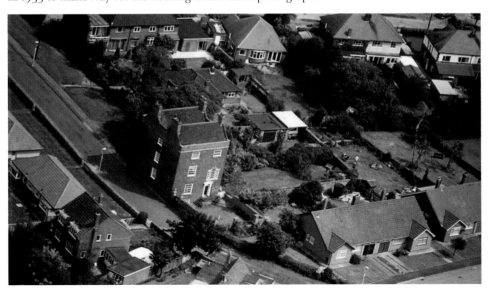

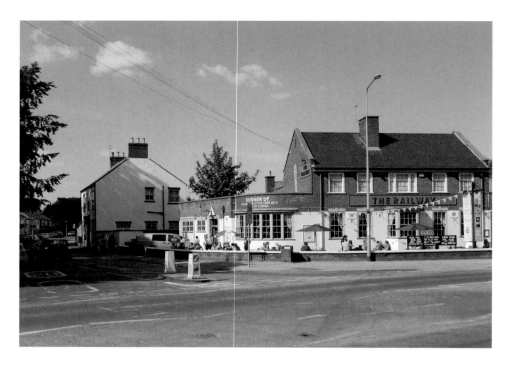

Railway Inn, Thwaite Street, 2013/1956

The modern pub on the corner of Beck Bank and Thwaite Street was built shortly after the 1956 photograph was taken, which shows L. M. Smith's corner shop, an empty cottage, and the gable end of the old Railway Hotel, of nineteenth-century origin. The Thwaite, named from a Viking word for a clearing, was once an area of open ground where fairs were sometimes held. From the eighteenth century the street became a fashionable location for the houses of wealthy Hull merchants.

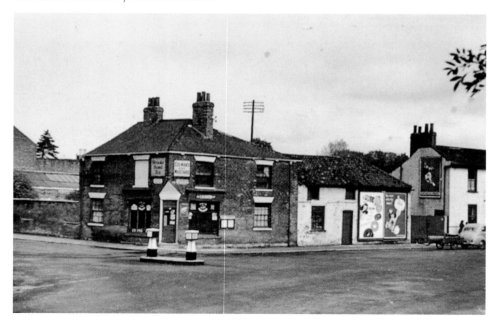

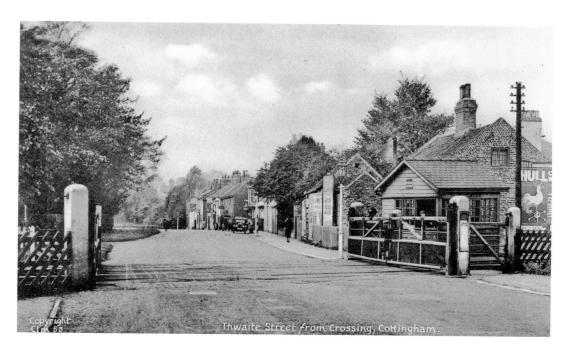

Thwaite Street from Crossing, Cottingham.

Thwaite Street Crossing Looking West, 1929

In 1846 the Hull–Bridlington railway sliced through Thwaite Street and began a history of traffic hold-ups when the gates close. The poster advertises 'Hull Civic Week', a 1929 British Pathé silent news film, subtitled 'Prince George flies to open famous Port's new Municipal Aerodrome, University College and Exhibition'. There is no sign of the Boer War gun that had stood beyond the gates since 1904 (see p. 96). In the modern view, the signal box and gates have been replaced by automatic lifting barriers.

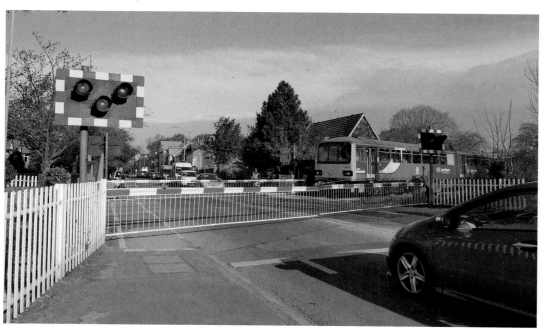

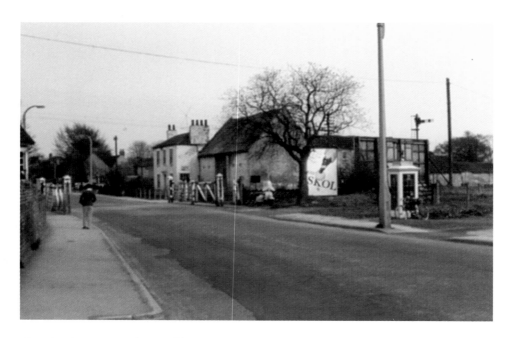

Thwaite Street Crossing Looking East, *c.* 1965/1980

One casualty of the late 1960s housing boom was Beechdale Farm and farmhouse on the south side of Thwaite Street, shown here shortly before the Beechdale and Crofters Drive houses were built. The barn in the older picture was superseded by a flat-roofed terrace of town houses (Beechdale Court). In the 1980 photograph the telephone box has changed its shape but not its cream colour. It is the icon of Hull's own telecommunications company (Kingston Communications), founded in 1902 and still independent of BT.

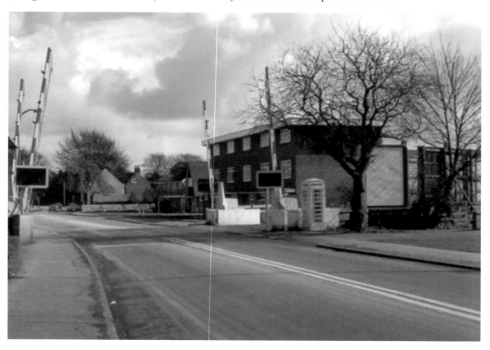

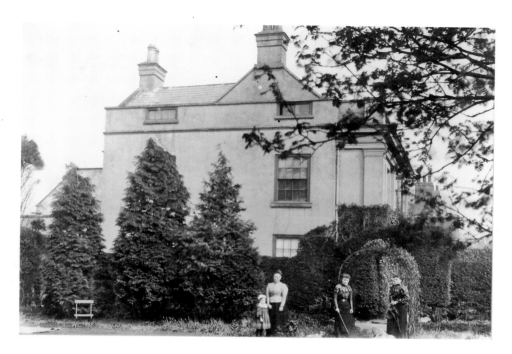

Thwaite Street 'Gentry' Houses

Tudor House, pictured in around 1910, is late eighteenth century, re-fronted in around 1830. William Tudor, a white lead manufacturer in Hull, owned it from around 1859. 'Bainesse' (below, built in 1870) was home in the 1920s/30s to Alice Holtby, the East Riding's first female county councillor and alderman. Her daughter Winifred, pictured with her, based her political novel *South Riding* (recently dramatised on BBC TV) on her mother's experiences. Mrs Holtby resigned from the council in embarrassment. From the 1950s Hull University used the house as student accommodation, renaming it Holtby House. It is now in private ownership again.

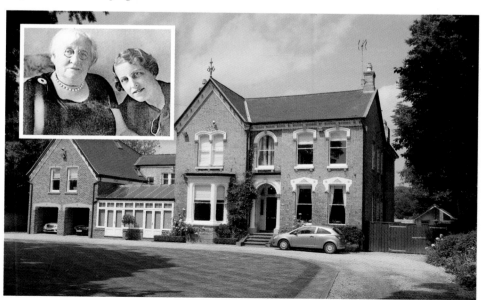

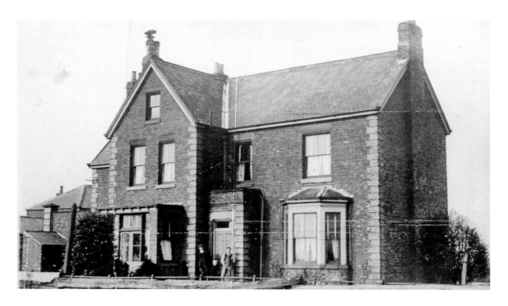

The West Bulls: Farmhouse, 1950, and Carvery Pub, 2013

This extensive dairy farm once provided daily milk deliveries throughout Cottingham. In the early 1940s Mrs Newlove started a Farmhouse Sunday school at the house, which stood on Bricknell Avenue opposite Strathcona Avenue. Out of it grew the Bricknell Avenue Methodist church. In the 1950s Hull Corporation bought the farm to extend the Bricknell Ave housing estate into Cottingham and in 1962 demolished the house. The West Bulls pub was named after it, replacing two of the farm's tied cottages at the junction with Hull Road.

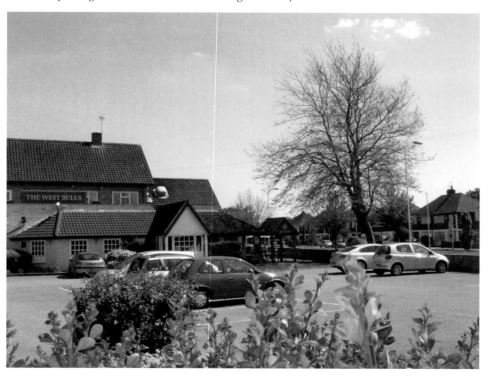

Beulah House, 285 New Village Road

It was designed by W. H. Atkinson and built around 1877 for William Fewster with a large garden, paddock, coach house (visible in the lower photograph) and stables. The upper photograph was sent from Mr and Mrs George Hill, pictured with their pet dog, as a Christmas greeting on 23 December 1906. A later resident, Captain N. K. Neilsen, rented the paddock to the Cottingham Recreation Club. Known as Beulah Ground, it was purchased in 1926 for £350 and is the home of the Cottingham Bowling Club. The house survives little changed, hidden in the lower photograph by the new housing that stands in the former garden.

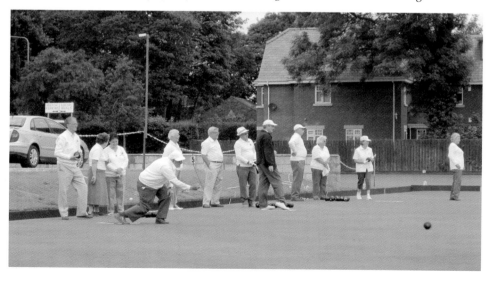

Endyke Lane, 1920s

This was once a 'green lane', following a medieval watercourse called *Navendike* that ran eastwards from Broad Lane Beck to the River Hull at Hull Bank. *Navendike* became *Nendyke*, then *Endyke*. The 2013 photograph, looking west, shows the post-1929 boundary between Cottingham and Hull. Before then, all of Endyke (alias Endike) Lane and the adjacent farmland belonged in Cottingham. The earlier photograph is probably from the same point, looking east. It is now a major traffic route, with housing developments from the 1930s onwards.

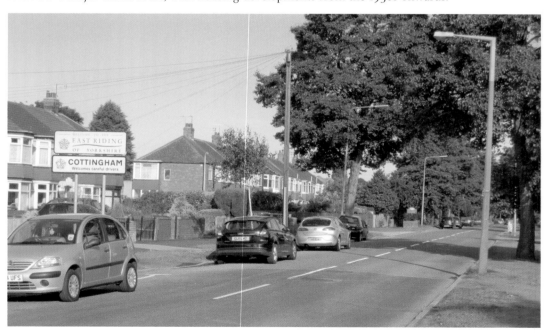

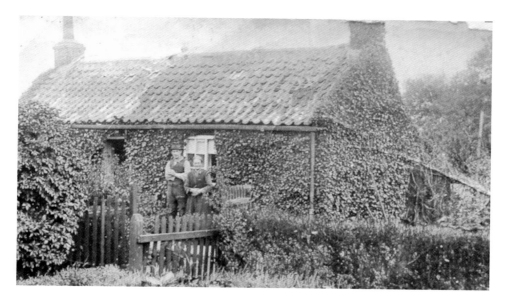

New Village and the Paupers' Gardens

In 1819, Thomas Thompson of 'Cottingham Castle' (p. 86) persuaded the parish's Overseers of the Poor to rent twenty allotments of church land to pauper families, in lieu of poor relief. These smallholdings, with tiny cottages built by the families themselves, ran north–south between Endyke and Middledyke Lanes and were called Paupers' Gardens. In 1826 the name was changed to New Village. Later occupants included James Coupland, market gardener, pictured in around 1900. The last surviving cottage (below, Endyke Lane) was demolished in 2012.

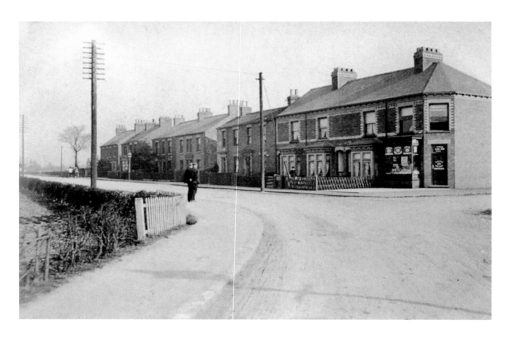

New Village Road, c. 1910

Originally called Inn Common Lane (the way to the village's inner common) it was almost entirely agricultural and home to market gardeners, cow keepers and dairymen. After 1820 it became the route to the 'New Village', and was officially renamed New Village Road in 1907, with the addition of Exeter Street, Devon Street and Cornwall Street (in the photograph) as side streets. Today it remains a popular residential area, with houses on both sides of what is now a busy route bypassing the village centre.

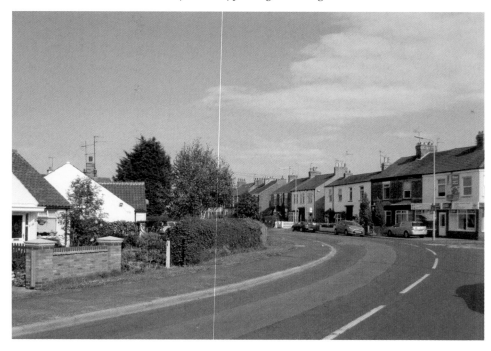

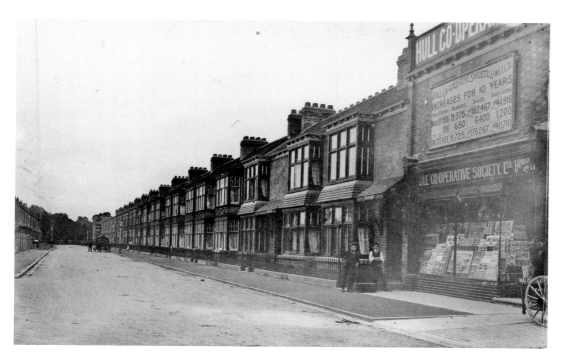

Exeter Street, *c.* 1909

Exeter Street was one of three parallel streets laid out in 1904–06 to house the village's increasing population. Close to the railway station, these neat terraced houses were popular with professional people needing easy access to Hull. The postcard, produced by the village postmaster H. J. Tadman, was posted in 1909. The shop at No. 2 opened in 1906 as Cottingham's first branch of the Hull Co-operative Society, and traded until 1967. Today the street has lost its uniform appearance and the shop houses a beauty salon.

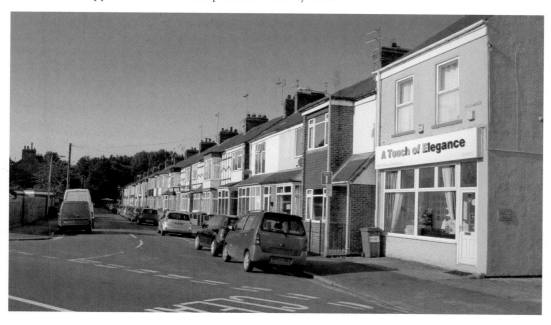

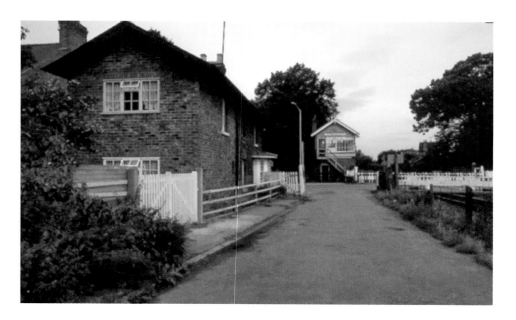

Crossing Cottage and Signal Box, 1978

The gatekeeper's cottage on Northgate was built for the opening of the Hull–Bridlington line in 1846. After the Second World War manual gates were replaced by power-wheeled ones and in the 1990s by automatic lifting barriers with warning lights and sirens. The North Box was erected in 1906. In 1987, after signalling transferred to Beverley, railway enthusiasts moved it to the Streetlife Museum in Hull, where Syd Williamson, retired signalman, is pictured below, visiting his old workplace in its new home.

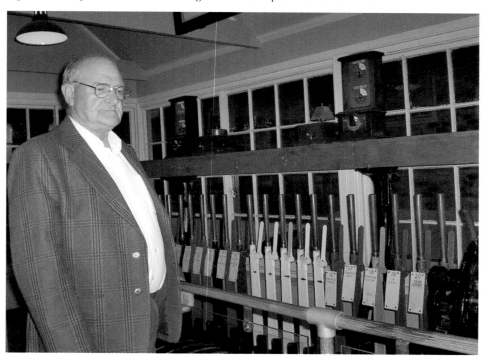

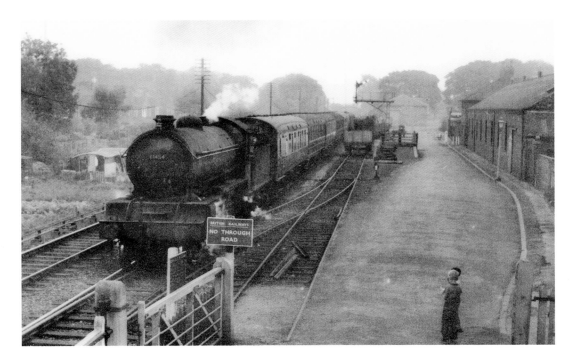

Station Mills, Northgate, c. 1950

From 1856–1902, Cottingham Gas Co. had its gasworks here, by the (sometimes equally pungent) railway goods yard (see p. 23). In 1904 the site was bought by Paley and Donkin, who built mill sheds (right) for weaving oil press cloth (see p. 29). From 1967, P&D spun yarn for Paton and Baldwin and wove carpets. Following the mills' closure in 1981/82, the buildings have been occupied by various businesses, including JaCee Print and Cottingham Cycles, run by three generations of the Dunn family, pictured below.

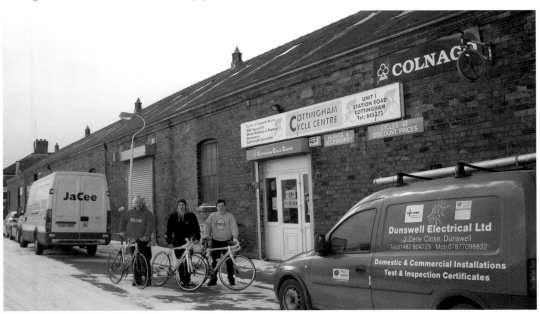

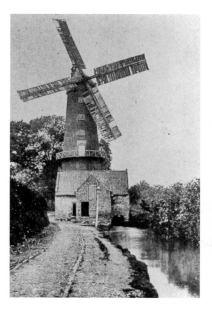
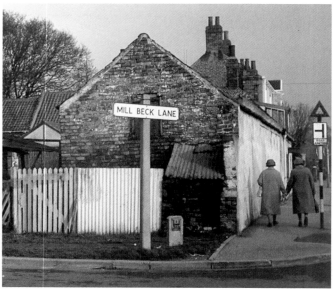

North Mill, *c.* 1880, and Mill Beck Lane, 1964

Mill Beck, running southwards against the lie of the land, was probably created in Anglo-Saxon times to provide water for a corn mill. Later known as North Mill, it was rebuilt as a wind and watermill in the nineteenth century but was demolished in around 1900. The beck was culverted to Northgate in 1958 as part of the Mill Beck Lane housing development. Lawson Avenue was named after the dairy farmer who owned part of the land and the now demolished barn and cottage on the corner.

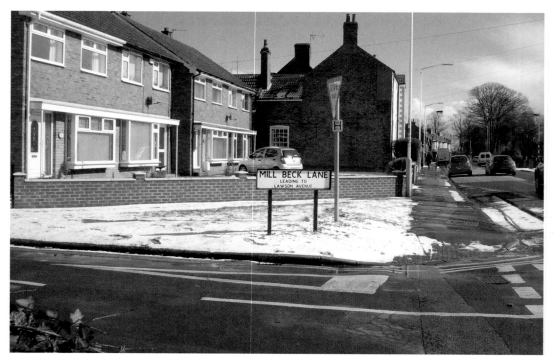

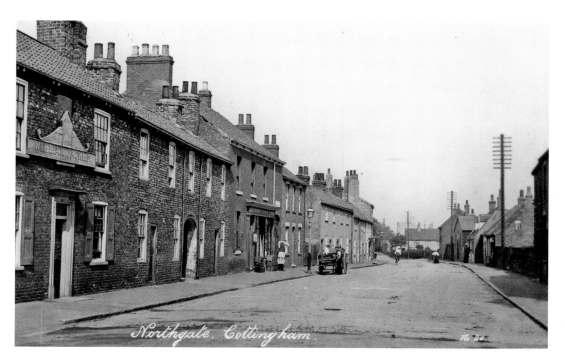

Northgate Looking East and the Cross Keys, 1905–06

The inn was licensed in 1823 and refaced in the 1920s. The rest of the terrace had an archway leading to a close of cottages called Providence Place. These were demolished to make an entrance to the inn's car park. The next building was a grocery and off-licence, run by Mary Brown in the 1910s/20s and Frank Wigby from the 1930s; it now provides dental services. The building before the second telegraph pole was Cottingham's first purpose-built Salvation Army Citadel (1888), its rental contract signed by General William Booth. Wasdale Green is now there.

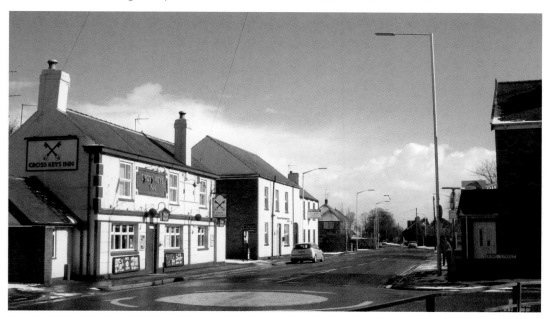

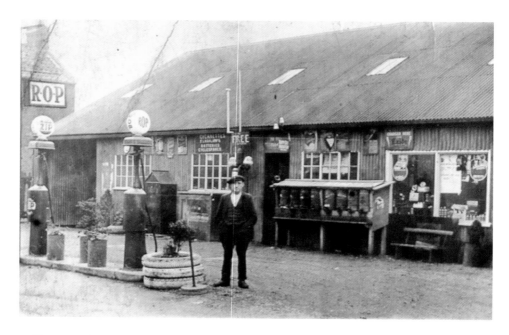

Selling Petrol in Northgate

In the 1930s, Raper's Garage sold ROP (Russian Oil Products), a cheap but controversial petrol, at first in 2-gallon cans and later from pumps. Free air and water were available. Standing on the forecourt is Jack Youngson, who lived opposite. The Raper family lived in a bungalow behind the garage and owned a large aviary full of birds, rabbits and guinea pigs. Since the 1970s it has been a Rix petrol station and is now Sewell's (selling BP), both of them local businesses, and is the only petrol station remaining in Cottingham. To its left is Wasdale Green.

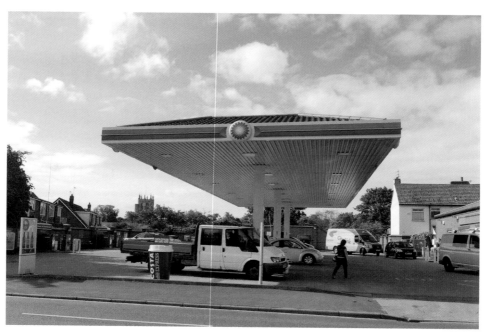

King Street North, Formerly Broad Lane, *c.* 1900

The stone-and-slurry road surface gleams with winter rain. On the right is the wall of 'Northfields', built around 1804 and enlarged in the 1820s. In 1928 it became a university men's hall of residence (Needler Hall), with considerable extensions in the 1930s and 1960s. Under the dip in the road runs Broad Lane Beck. In the left distance is the garden wall of the Rectory, now the site of Hallgarth residential home. In the right distance a cart stands outside the yard of John Henry Wright, smith, builder, joiner, wheelwright and undertaker. He had another yard in Hallgate (p. 55). In the picture below he stands on the far left, next to his father John Wright, a wheelwright, with a farm rully made for James Richardson, a Cottingham market gardener. Wright's house is on the right and the Primitive Methodist chapel is on the left.

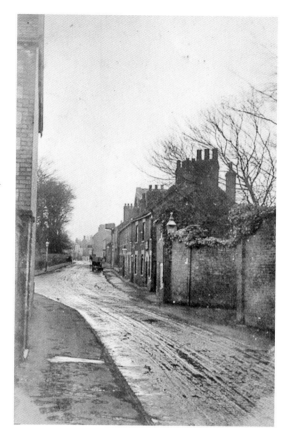

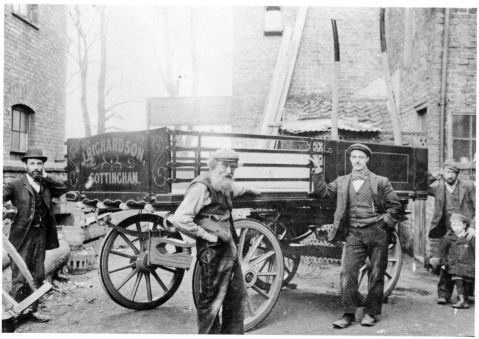

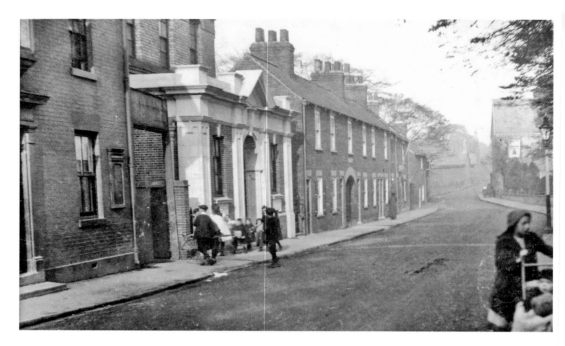

Primitive Methodist Chapel, King Street, After 1915

The chapel was built in 1861. The photograph shows the classically inspired entrance that was added in 1915 and the Wright's House (left, see p. 45) before it was demolished to make way for further chapel extensions. These now almost conceal the original building. The chapel closed when the merger with the Wesleyans in Hallgate occurred in 1937. After the Second World War it became a grocery warehouse (Jarman & Flint) and then Health Authority offices. From 1983 to 2013 it housed Modus, an interior design firm.

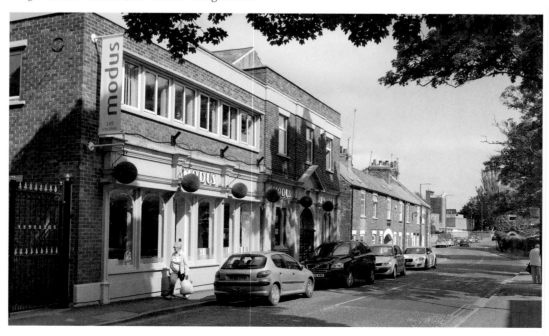

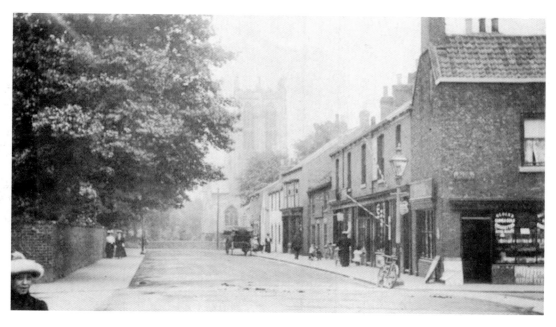

Hallgate/King Street Crossroads, *c.* 1900/Early 1950s

On the corner is Richard Marshall's. In 1913 it became the Midland Bank, which by around 1930 had a new doorway on the corner. Hatfield's horse bus is parked outside his stables. Horse droppings are visible on the crossroads. Except for the very rich, everyone in 1900 walked, cycled or had horse transport. The impact of motorisation is evident in the 1950s photograph, where Cusson's grocers is on the opposite corner (now John Ford's menswear).

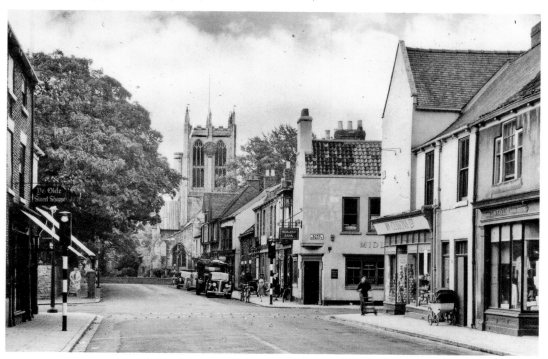

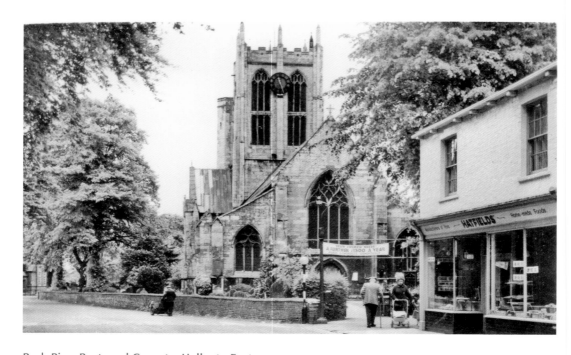

Pork Pies, Post, and Carpets: Hallgate East, 1950s

For years the aroma from pork butcher Hatfield's bakery was enjoyed by children on their way to school. Originally it was two shops: Hatfield's, and the first post office in Cottingham, which was run in 1892 by Hugh Richardson, and later by brothers Herbert and Harold Tadman, both postcard producers. In 1910, Harold Tadman moved the post office to Ivy Leigh in Hallgate (p. 56). In 1970 Paley and Donkin opened their shop here to sell carpets, originally from their factory at Station Mills (p. 41). The business is now owned by Leighton's.

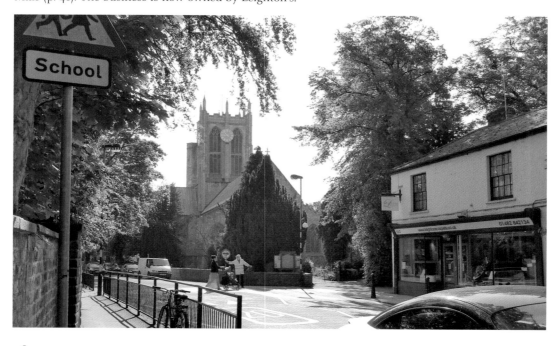

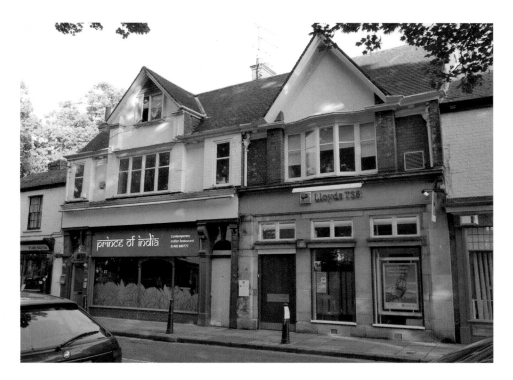

Hallgate East, 2013/Early 1900s

The Indian restaurant occupies Sartor House (Latin *sartor* 'tailor'), built in 1913 for Walter Pybus, 'High class Bespoke Tailor, Costumier and Breeches maker'. It was one of the first houses in the village to have a water closet, instead of an earth closet, and later electricity and a telephone. His main trade came from funerals, liveries for chauffeurs and children's uniforms for Hallgate School. Its other half – now a bank – was Tutill's the draper, with Bon Marché (ladies' wear) upstairs.

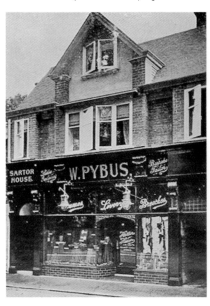
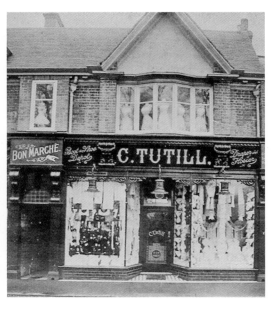

49

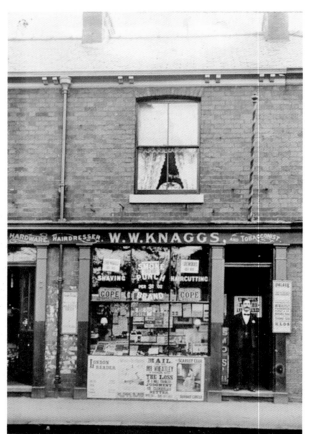

A Hallgate Barber and Newsagent, *c.* 1905

William Knaggs, pictured in his doorway, moved to Cottingham from Hull with his family in 1899, setting up shop as a hairdresser, newsagent and tobacconist. The advertisement on Knaggs's left promotes a show at the Palace Theatre, Anlaby Road, Hull. The *Hull Mail* placard on his right headlines the loss of a Hull fishing trawler, while the one next to it advertises *The Scarlet Clue* by bestselling novelist Silas Hocking, published in 1904. Like other newsagent-cum-barbers, Knaggs produced postcards of Cottingham (see p. 2). From around 1913 these premises (No. 133 Hallgate) were occupied by Richard Marshall, who had moved there from round the corner in King Street, and in 1925 by Herbert Beal. They too were newsagents, tobacconists, barbers and postcard publishers. In the 1950s photograph below, the logo of William Jackson's grocery, later Grandways supermarket, is on the right-hand corner.

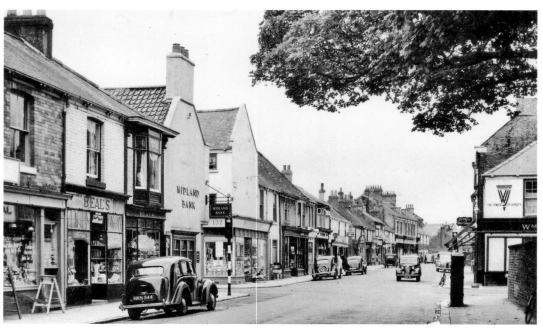

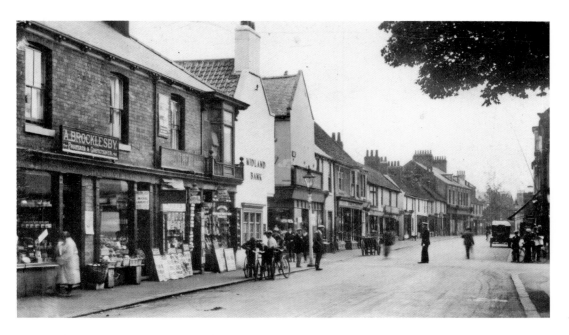

Hallgate/King Street Crossroads, Late 1920s

Arthur Brocklesby's grocery store, next to Herbert Beal's newsagent's and barber's shops, was one of four that he opened in Cottingham between 1911 and 1939. Since the 1990s it has been a delicatessen. Note the flat-capped policeman on point duty at the crossroads, a response to increasing motor traffic in the 1920s. His job was superseded by automated traffic lights in the early 1930s, some of the first in the country. In the late 1950s Beal's shops became the end bays of an extended Midland Bank (now HSBC), and the façade was changed to match.

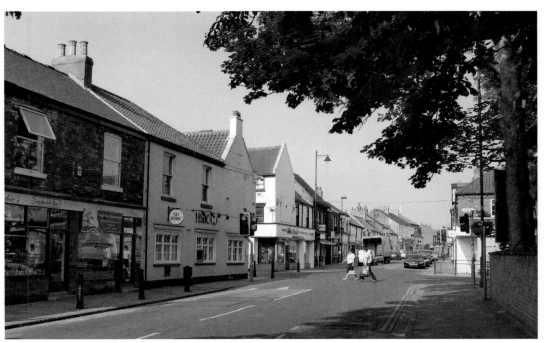

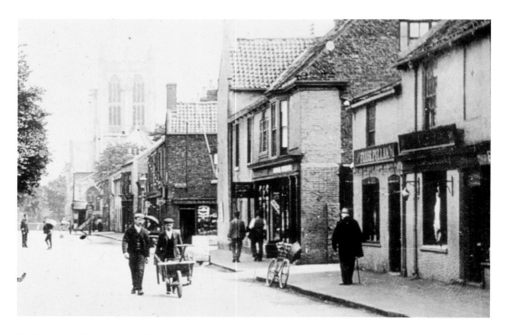

Pullan's and Dixon's, Before 1905

Frank Pullan, beef butcher, came to Cottingham from Otley in around 1900. His shop (second from the right) appears in its original form, before it was redesigned by Alfred Lawrence and built in its present shape in 1905. It still flourishes, though after three generations it is no longer owned by the family. Beyond Pullan's is Dixon's chemist, now Coopland's bakers. When Mr Dixon died in the early 1900s, his niece Miss Maisie Wright, renowned for her cures, took over the shop. 'She was a wizard at mixing up ointments and medicines for any complaint that flesh is heir to...' (Eileen Green).

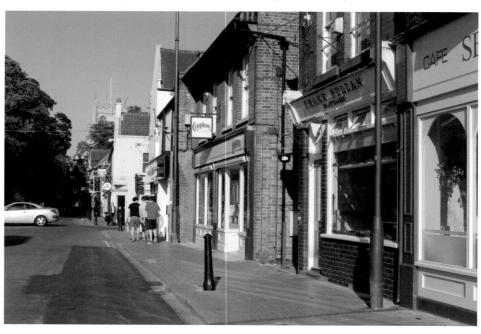

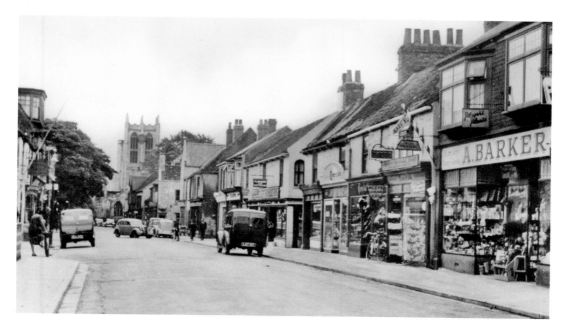

Hallgate South Side Shops, Late 1930s

In the 1930s, Hallgate's shops were individually owned and run by local families, providing for everyone's daily needs, whether in new goods, repair services, or tools and materials. Barker's (newsagent, stationer, tobacconist, postcard publisher, toy and sweet shop and, at the rear of the shop, barber) was opened in 1924 by Albert Barker next to Dixon's and moved to its present premises in 1934. The 2013 photograph was taken on Cottingham Day, when the street was closed to traffic.

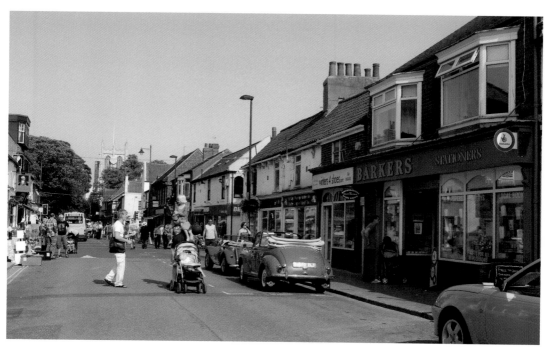

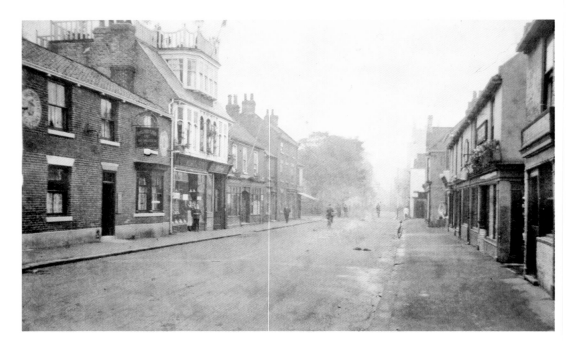

Mudd's and the King Billy, *c.* 1910

One of Cottingham's most unusual buildings was designed by Alfred Lawrence for J. H. Wright, who built it in 1908–10 on the site of an old cottage next to his Hallgate yard entrance. It incorporated a tiny contractor's office for himself (right of the lower photograph) and a downstairs shop, leased to Charles Mudd the grocer. The luxury flat above was for the Wright family (it is now a hairdresser's). The veranda was taken down by 1920 as it was unsafe. On its other side is the King William IV, built around 1800 and known as the Prince of Wales before William became King in 1830. In 1893, the pub was sold to the Hull Brewery Company, whose round nameplates are on the front of the building.

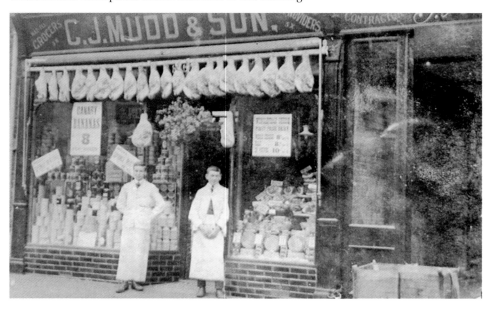

Mudd's Yard, *c.* 1906/1970
This postcard, stamped 1906, shows Wright's contractor's yard before he built Mudd's shop. Wright stands at the back, second from the right. Front left is Robert Kirby, the King Street cab driver. The rear warehouse was George Bland's forge. In the 1930s it became Edward (Eddie) Stroud's shoe repairer's, a trade started in Cottingham by his father Henry in 1916 and continued at various shops by Eddie and his brothers George and Richard. The upper floor was rented by Eddie's father-in-law, Elvin Alphonso Soames, a sugar boiler. Eddie's son, 'Little' Eddie, remembers as a boy helping Grandfather Soames to make boiled sweets of different shapes and sizes, which were sold from a horse-drawn van every Saturday at Beverley market. In 1987 Eddie Stroud retired. The rear building was demolished, and the yard and Wright's minuscule office are now 'Hallgate Landscape Centre'.

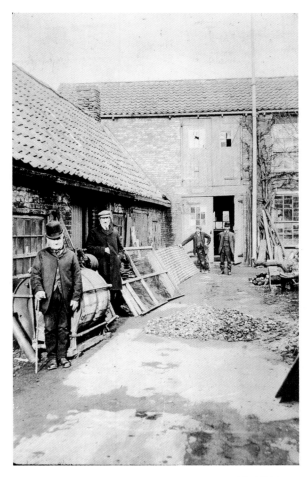

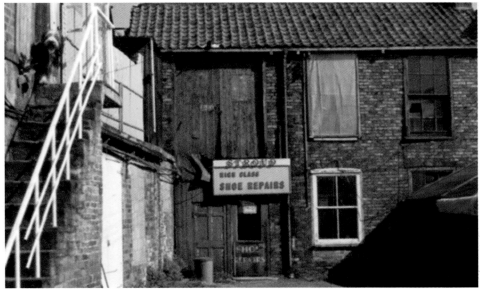

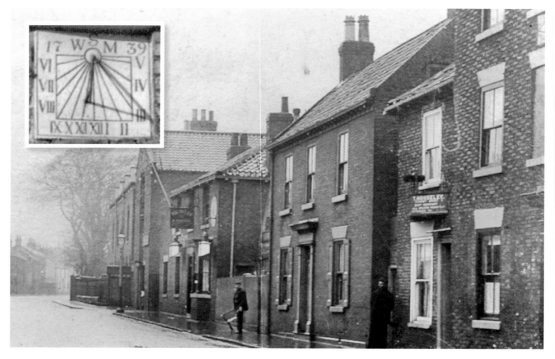

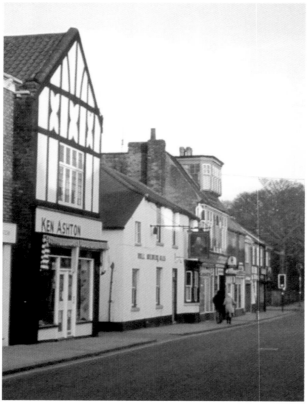

Hallgate North Side,
c. 1904/1970s–80s

The sundial, top right and inset, was removed from St Mary's church in 1853. The buildings from the right are: Thomas Houseley, chimney sweep (the brush is above the name); Ivy Leigh (eighteenth-century residential), which J. H. Wright converted in 1908–10 to house the London Joint Stock Bank and Tadman's post office (currently Alterframe and Thomas Cook); Wright's builder's yard; King William IV pub, with lamps. Then, tall and narrower, Ness's the corn merchant's warehouse (nineteenth century) with the pub's malthouse behind. In 1939 the warehouse was sold to Arthur Brocklesby, who altered the frontage for one of his grocery stores. In the 1970s/80s it was Ken Ashton's garden and pet food shop. Members of the Ashton family at various times also ran a grocer's and fruiterer's, a hardware and cycle shop, and were well-sinkers, plumbers, electricians, and cycle and motor repairers.

Rydale, *c.* 1910

As well as smaller houses, there were larger residences on Hallgate with small front gardens and railings, as can also be seen on the next page. Over time many of these houses became shops or services, including Rydale, built around 1820. In the 1930s, bay windows replaced the original sash windows. Following post-war road widening, its railed garden became the new pavement. It is now almost unrecognisable as the NatWest Bank, complete with a well-used 'hole in the wall' cash dispenser.

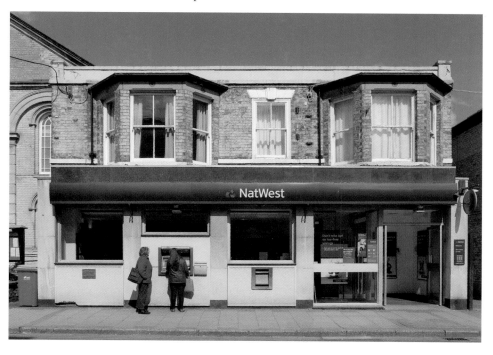

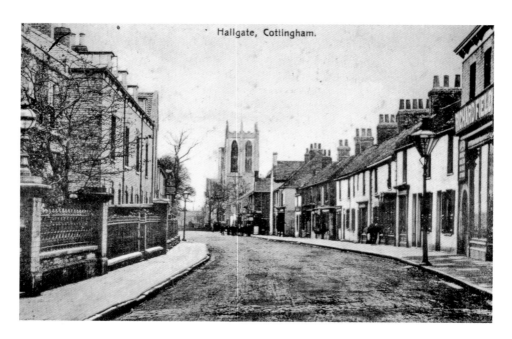

Hallgate, Cottingham.

Hallgate, *c.* 1900/Christmas 2012

In the 1930s, Field's (on the right, now replaced by Oxfam) was 'a high-class grocers, whose shop always had a beautiful aroma of fresh ground coffee. [They] used to supply our groceries a week at a time. When the day came that the traveller brought along samples of boxes of chocolates, fancy boxes of biscuits, and jars of barley sugar, glacier mints and humbugs, I knew Christmas was getting deliciously near' (Eileen Green). Since 1981, Christmas has been marked by festive lights in Hallgate and King Street.

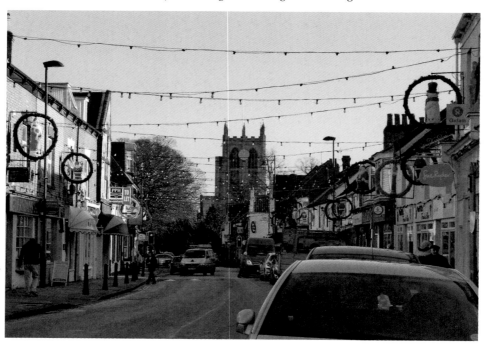

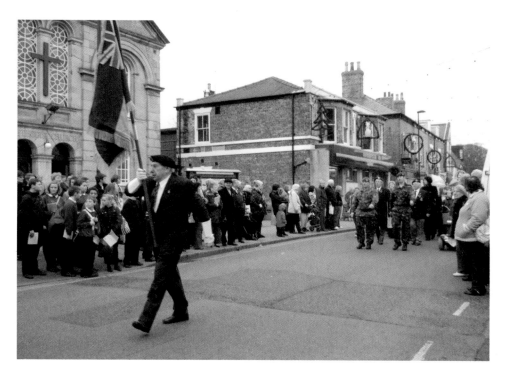

Hallgate Ceremonial Processions

Hallgate, the central spine of the village, is a principal route for Cottingham processions. The top photograph shows the procession to the Memorial Gardens next to the Methodist church on 11 November 2011, for the rededication of the memorial plaques on the gates (p. 60). The plaques, in memory of the fallen in both World Wars, were cleaned and additional ones made, and the fencing, gates and lamps were repaired. The bottom photograph shows the St John's Ambulance cadet band in 1943.

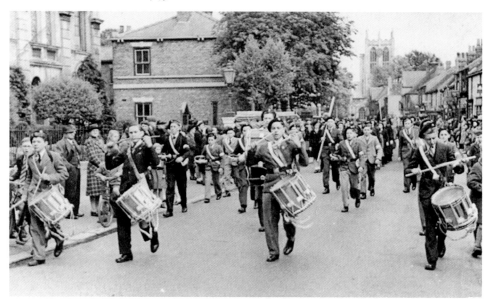

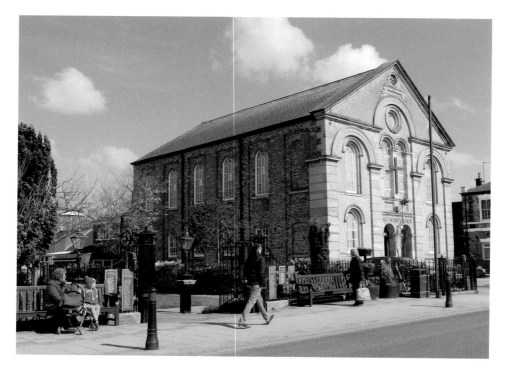

Methodist Church, 2013/Interior Early 1900s

The largest building in Hallgate west, the Methodist church was built in 1878, replacing a smaller chapel on Northgate (see p. 75). To the rear of an adjacent paddock was the church schoolhouse, which in the late 1970s was demolished to build a supermarket (currently the Co-op). In 1928 the paddock became the Memorial Gardens, commemorating 105 Cottingham men killed in the First World War. The church has long been a social centre and hosts the annual Cottingham Musical Festival. The bottom photograph shows the original interior, which with its gallery could seat nearly 600.

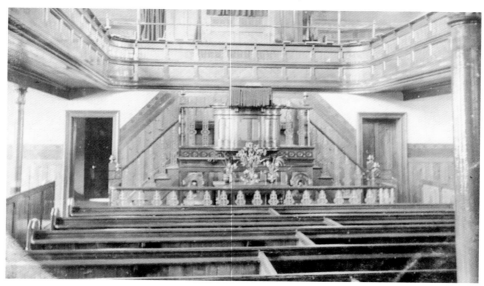

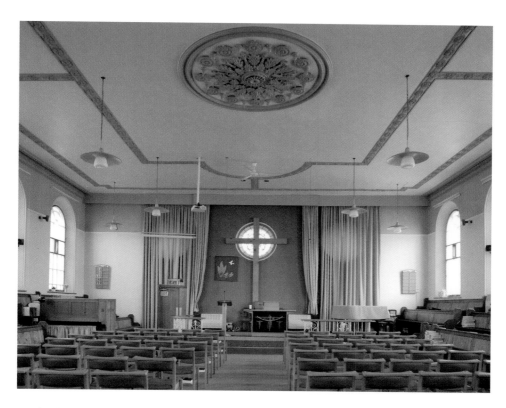

Methodist Church Interior

The selling of the schoolhouse helped to fund a radical change to the church interior, turning an old-fashioned, scattered and uneconomic building into 'a suite of premises which is more comfortable and welcoming ... [and more suited to] the work of the church in the local community'. In 1977 the single internal space was converted into two separate floors, a church above (seating over 200) and at ground floor a vestry, kitchen and popular social hall with a variety of public uses.

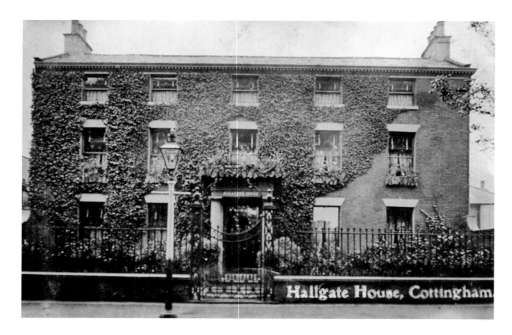

Hallgate House, Cottingham.

Hallgate House, *c.* 1910

This was built between 1779 and 1789 for John Wray, a Hull merchant. It had large gardens going back to Finkle Street. By 1937, the imposing entrance, front garden and railings had gone and it had become a Co-operative Society shop. It now has flats in the top floor, a dentist on the first floor and, extended forward, shops on the ground floor, a mixture of residential, service and retail so characteristic of the centre of Hallgate.

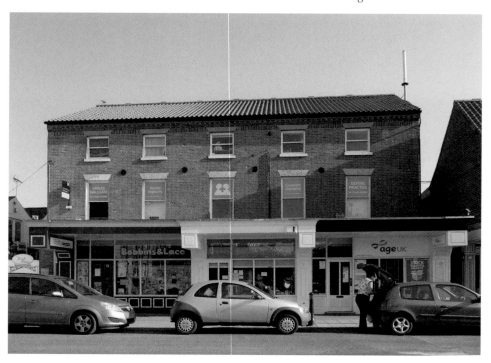

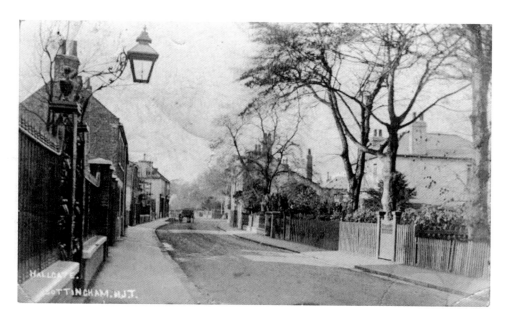

Hallgate West from Hallgate House, 1910

In this postcard by Cottingham's postmaster, Harold Tadman, the elegant lamp guards the entrance to Hallgate House. Opposite is No. 190's garden and the paddock that became the Memorial Gardens in 1928 (pp. 59–60). The white house (No. 192) is dated 1817. The poet Philip Larkin lodged here in 1955 but found the daughter of the owners too noisy and moved away. He is buried in Cottingham Cemetery on Eppleworth Road. In 1910 this end of Hallgate was all residential but on the south side the shops now extend to George Street.

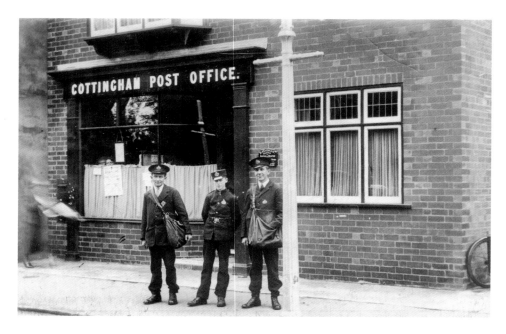

Tadman's Post Office, 1930s, Arthur's, 1979

Tadman's first post office was at No. 117 Hallgate (p. 48), but moved in 1910 to No. 144 (p. 56) and then in 1933 to Nos 189–191, which was specially rebuilt for Mrs Tadman. She also inherited the postmaster's role as Cottingham's registrar of births and deaths. In the 1970s Arthur Barnard converted it to 'Arthur's Distinctive Male Attire', later demolishing the cottages next door to build 'Barnard Court'. It is still a locally run shop (Ian Black's) selling quality domestic appliances.

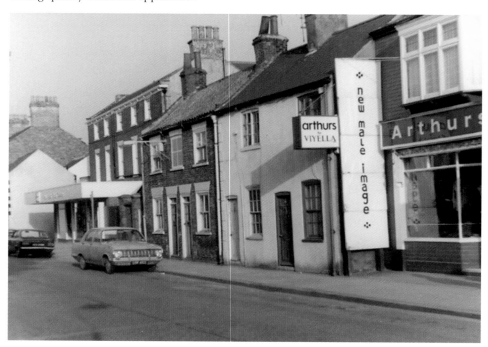

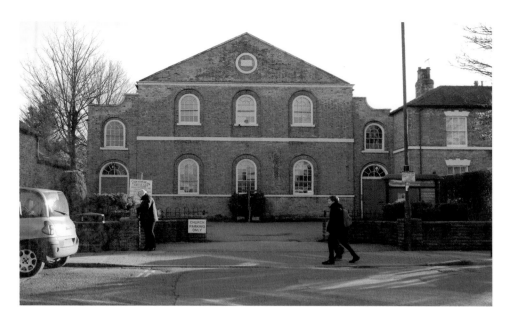

The Zion United Reformed Church

The first Zion chapel, erected in 1692, was replaced in 1819 by this Grade II* building, described by Pevsner as 'one of the finest Nonconformist chapels in the Riding ... It is all plain and honest and peaceful.' Its slender pillars, gallery, pulpit and box pews survive intact, making it one of Cottingham's most beautiful interiors. The organ, built by Forster & Andrews of Hull, dates from 1896 and retains the original hand bellows. The chapel manse next door was built 1852–65 and is now a private house.

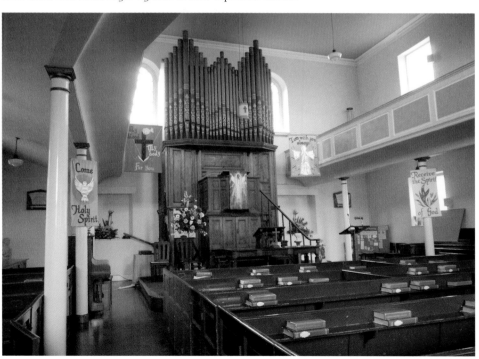

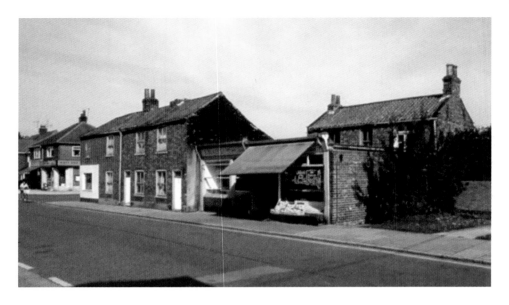

Signs of the Times: Hallgate–George Street, 1978

The cottages in the upper photograph were demolished in 1985/86. The new building currently houses an estate agent, solicitors, ladies' hairdresser and Italian takeaway. Next door, the cooked food of Chinese and Bangladeshi takeaways have replaced the fresh food of Blades the fishmonger and Overfield the greengrocer. Beyond George Street, the pair of semi-detached houses, once occupied by West End News and Thompson the butcher, are now a café/restaurant and a mobility centre supplying electric buggies and other equipment for the elderly and disabled.

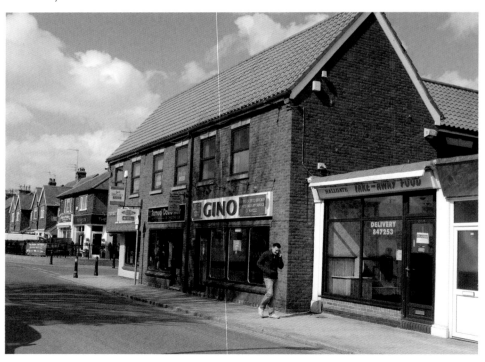

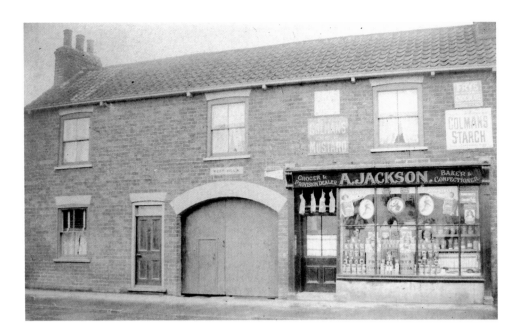

West Villa, Early 1920s

Nowadays there are no shops west of George Street corner, a natural boundary between the shopping and residential areas of west Hallgate. Mr Jackson, grocer and provision dealer, baker and confectioner, sold his half of West Villa (built late nineteenth century) to the Kemp family in May 1926. The Kemps extended their undertaking business from Hull to Cottingham in the 1930s and in 1958 moved their entire business down the road to Nos 259–61 Hallgate, where it is still run by the family.

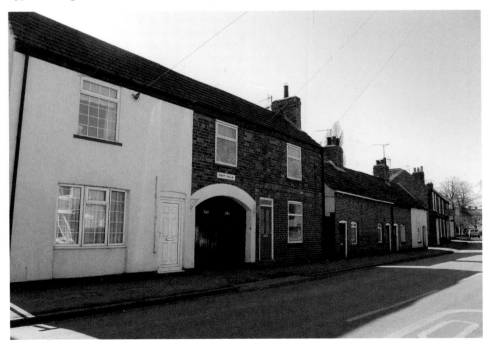

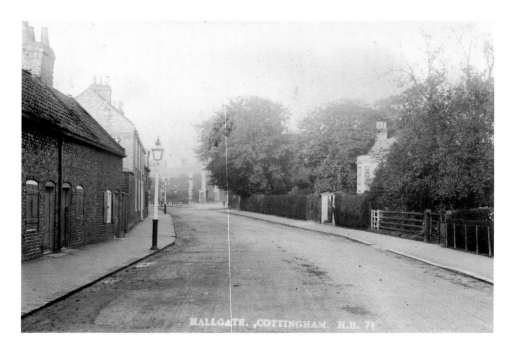

Hallgate West, After 1913

In Herbert Beal's postcard, 'The Beeches' (built around 1830) is just visible in the trees. It was once the most western house in Hallgate. In the modern photograph it is hidden behind the evergreens of the garden next door, but is essentially unchanged, as are the four cottages on the left (1787–1828). The detached house beyond the cottages was Hopper's dairy farm until 1958. It is now Kemp's funeral undertaker's, advertised by the blue sign. In the distance is Westfield House, now the Fair Maid pub.

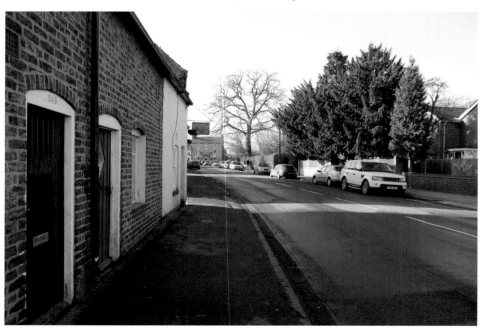

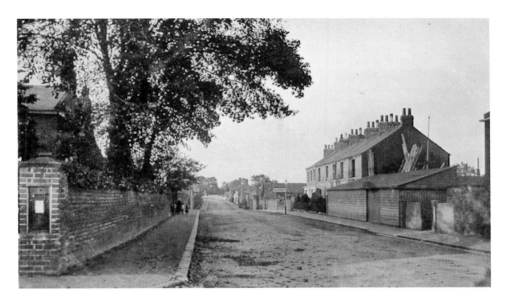

George Street Looking North from Hallgate, *c.* 1905

George Street was built by (and named after) George Knowsley, a wealthy Hull wine merchant who acquired a large area of west Cottingham in the late eighteenth century. By 1792 he had already bought part of the medieval castle grounds, through which he drove the new road, replacing an old right of way linking Hallgate with Northgate. On the left is 'Thorncliffe' (built 1806–10), now replaced by some semi-detached houses, a terrace called Thorncliffe Gardens, a café and a shop (p. 66).

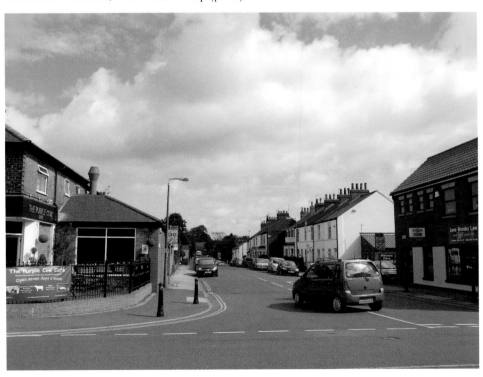

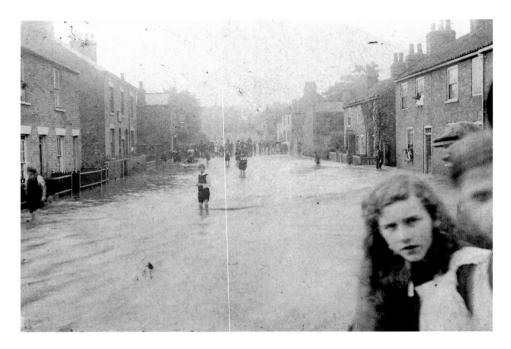

George Street/Crescent Street Floods, 1912/2007

George Street dips down across the valley of Broad Lane Beck, which Knowsley culverted under his new road in around 1804. The beck flows intermittently, fed mostly by field drains on Harland Way and Eppleworth Road, and occasionally by Keldgate springs (on Eppleworth Road), which erupt when the water table is high. In freak storms George Street and Crescent Street are prone to flooding, the worst of them on 12 July 1912 and 25 June 2007, when many parts of Cottingham turned into rivers.

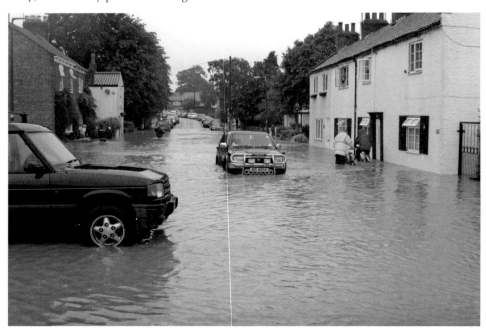

Crescent Street, 1950s/2007

Crossing George Street alongside the beck, Knowsley built the inappropriately named Crescent Street. In the far distance, trees screen the mound of Baynard Castle. The semi-detached houses were built around 1805–10. They and the garage, accessed by a bridge across Broad Lane Beck, were demolished in the 1960s to build council flats. The unmade lane was then tarmacked and the beck culverted, but with inadequate capacity. In the 2007 flood, the force of the beck water blew the manhole covers off, creating fountains.

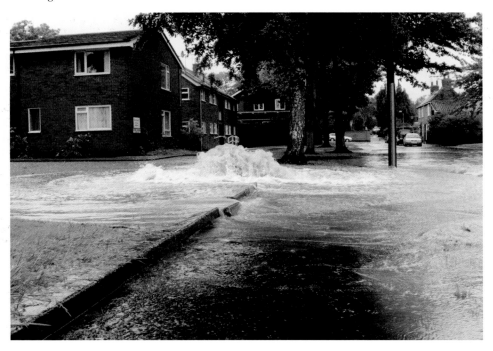

The Lamplighters, Early 1900s

When the Cottingham Gas Co. merged with the British Gas Light Co. in 1902, there were 135 gas streetlights in Cottingham. They were tended by George Arthur Akam, seen here (in a postcard by William Pickering) with Dick Holiday at the George Street–Northgate junction, equipped with lighting poles. Behind them is the wall of Park House. Northgate, once a turnpike road, is now a busy road and bus route, with electric street lighting and flashing belisha beacons for safer pedestrian crossing. On the right of the lower photograph is George Akam's great niece, Dorothy Catterick (*née* Burrell).

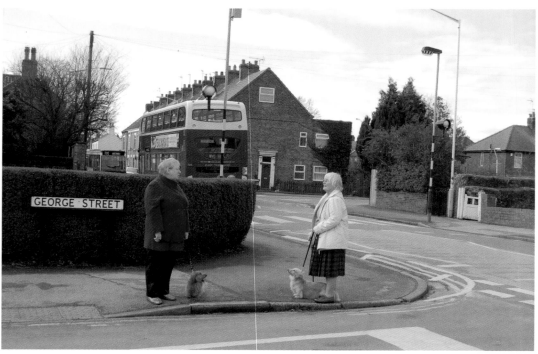

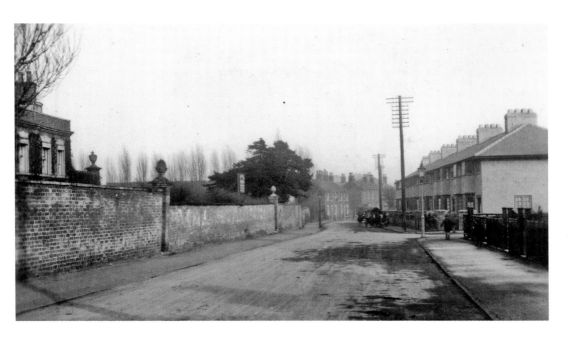

Park House, Northgate, Late 1920s

Park House was built in the late eighteenth century at the south end of Cottingham Parks, which comprise 500 acres of former medieval deer park. In the second half of the nineteenth century the house was owned and enlarged by Thomas Wilson, founder of the Hull shipping line. It became a private school in 1926 but was demolished in around 1933, when the house and front garden were replaced by the terrace of houses on Northgate, known as Plummer's Row after the builder.

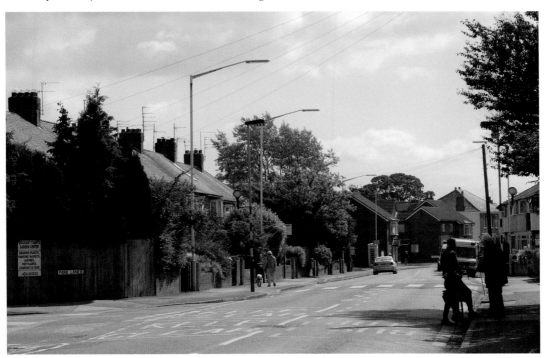

King George V Playing Fields, 1950s

After Park House was sold in the 1930s, its extensive grounds became a public recreation area, still known locally as the 'Rec'. In 1950, however, it was newly named King George's Field, one of many similarly named free public recreation grounds governed by the rules of a nationwide trust. It is now run by East Riding Council in partnership with KGV Cottingham Community Trust. The current pavilion was built in 1987. The entrance has since been widened but retains the original stone carvings.

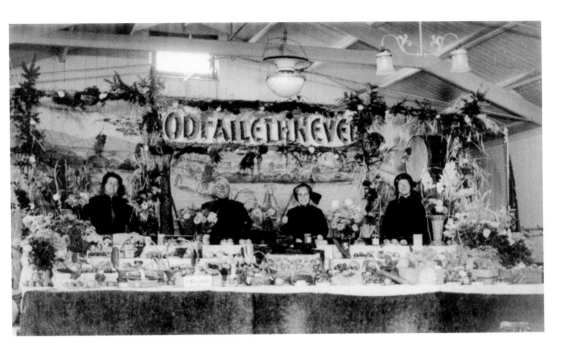

'God Faileth Never': Salvation Army Halls

The Harvest Festival display (perhaps 1940s) shows the inside of the first Salvation Army Hall (a nineteenth-century wooden building with gas lighting), with the drum and flag on the right. It stood on land south of Northgate (see p. 43) until it burned down in 1958. In 1959 a new brick hall was opened on the north side of Northgate (middle photograph, 1970s). This was the site of the old Weslyan chapel, which had been built in 1803 with money from Thomas Thompson of 'Cottingham Castle'. When the Salvation Army corps closed in 1997, the hall was demolished and replaced by maisonettes. Next to it is the Cottingham Rifle and Pistol Club.

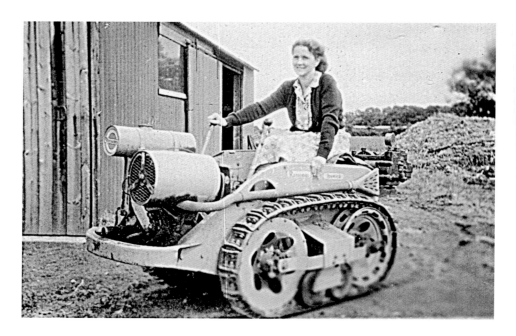

Market Gardening in Park Lane, 1946

A ready water supply from boreholes and good arable land enriched by Hull's 'night soil' (human waste from dry closets) made Cottingham ideal for market gardeners. There were seventy-six listed in Kelly's 1905 directory. In the 1930s, Dutch settlers introduced their efficient 'Dutch lights' greenhouses. Cottingham still supplies the nation with salads. Charles Horsley and his wife Violet (on their new Ransomes MG2 tractor above) worked Horsley Bros' 9-acre smallholding off Park Lane for almost fifty years. Their borehole pump house is on the left. The site is now Lawson's plant centre.

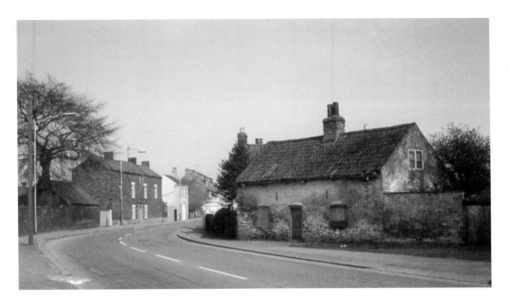

An Eighteenth-Century Farmhouse and Cottage, Northgate, 1985

The brick farmhouse on the left in the upper photograph was leased in 1798 by George Knowsley to market gardeners William and Ann Allan. Their family lived there until the late 1980s, when the house was sold and converted into four dwellings and a flat. Most of the market garden was sold in 1964 for new housing (Grange Drive). It was Knowsley who in 1792 created the street bend, bringing part of the castle's outer moat inside the grounds of his house, which formerly stood to the left of the farmhouse. The eighteenth-century cottage on the bend, mysteriously known as 'Click'em in(n)', was completely rebuilt in 1985/86, including use of the old bricks.

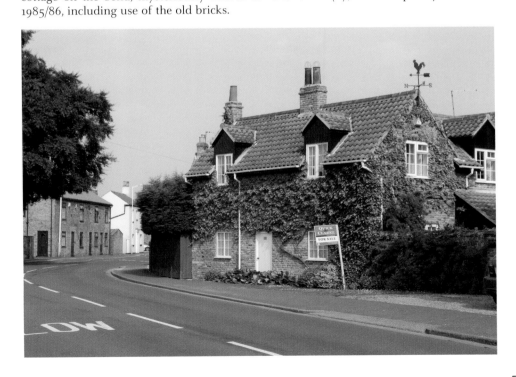

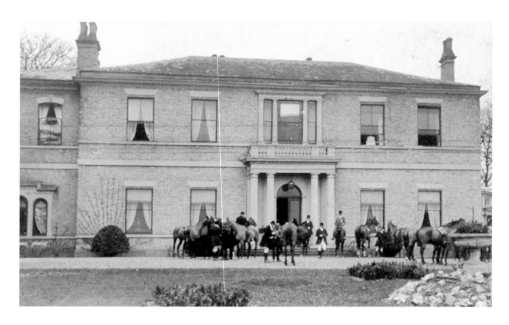

Cottingham Grange, *c.* 1915, and the High School

The Holderness Hunt gathers at Cottingham Grange on Harland Way, the westward continuation of Northgate. George Knowsley bought the estate and built the house by 1802, demolishing his old home in Northgate. From the mid-nineteenth century until it was sold in 1930, it was owned by the Ringrose family. The house was demolished by 1936. In 1955 Cottingham County Secondary School (now Cottingham High School) opened on the site of the house, retaining in its grounds many mature trees from the area known as Hyde's Wood.

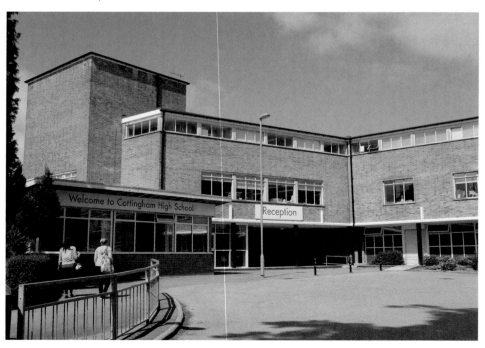

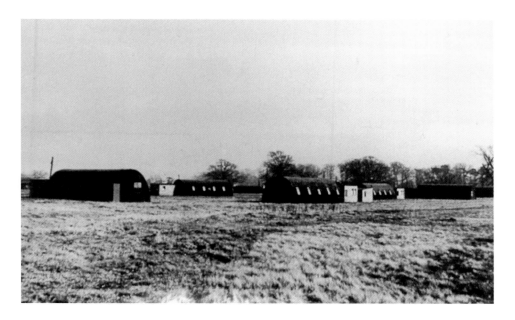

The American Army Camp, 1948, and the Lawns

During the Second World War, a refugee camp of Nissen huts, for housing potential Hull evacuees, was built in the grounds of Cottingham Grange near the junction of Northgate and Harland Way. The camp was actually used in 1944 to house black American troops, who made quite an impact on the young ladies of Cottingham. A brick Guard House was built to house the senior officers. In 1951 it became 'Camp Hall', accommodating students at University College Hull. It was demolished after the new University of Hull opened Ferens Hall (incorporating the Guard House) in 1957. In the mid-1960s a Grade II* listed suite of six additional halls (The Lawns) was built on the camp site itself.

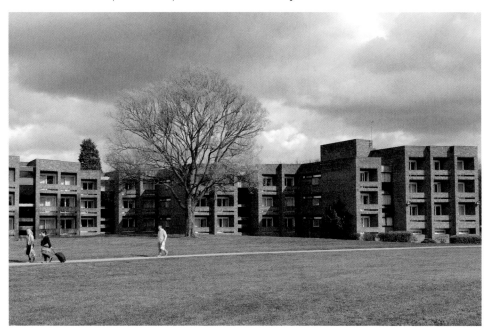

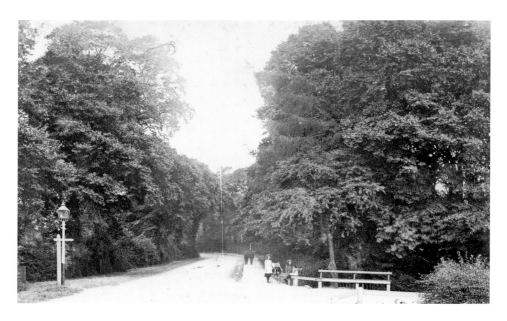

West End Road–Eppleworth Road Junction, *c.* 1906

Running from Northgate/Harland Way to Hallgate, West End Road was once a tree-lined country lane marking the boundary between the castle and the medieval west field, which was enclosed in 1793. Westfield House garden wall was on the far bend, now the junction with Dene Road. The ditch on the right, now culverted, reappears in Hallgate as Broad Lane Beck. In the late 1920s Fred Whiting began house-building here, followed by Percy Buckle in the 1930s with Jesse Taylor's distinctive style of high pointed roofs (on the right).

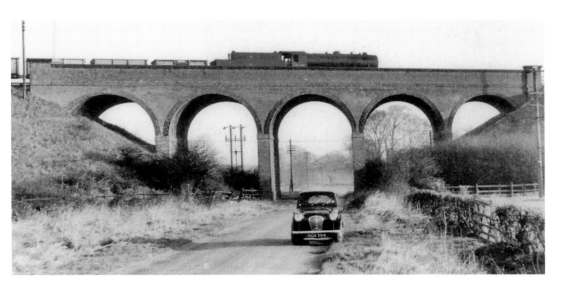

Five Arches, 1950s/1977

The Hull & Barnsley Railway opened in 1885, carrying freight and passengers until 1964. The line here ran between Willerby and Little Weighton. The viaduct crossed Westfield Road, the continuation of Eppleworth Road towards Raywell. For motorists it seemed like a gateway to Skidby and Cottingham just west of the hamlet of Eppleworth. The upper photograph looks east. The lower photograph, looking west, shows the viaduct being demolished by British Rail in 1977. The land is now owned by a quarrying and waste disposal company.

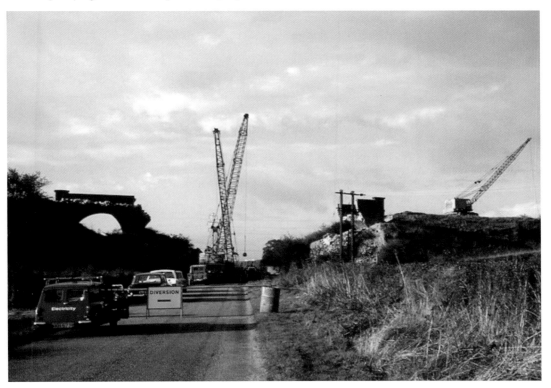

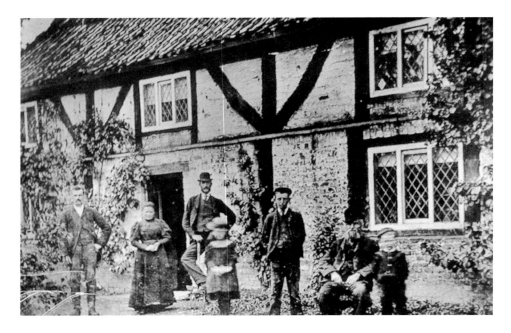

The Manor House and Kirk Family, 1890s

This late sixteenth-century house is at the end of a private road off the west end of Hallgate ('the street leading to the Hall'). The porch was added in the 1960s. Built on the massive mound of the twelfth-century 'Baynard Castle', 'the house ... is one of the best surviving timber-framed farmhouses in the East Riding' (Pevsner & Neave). The mound was encircled by earthen ramparts and two huge moats. A section of the outer moat forms the back garden of houses on the east side of West End Road.

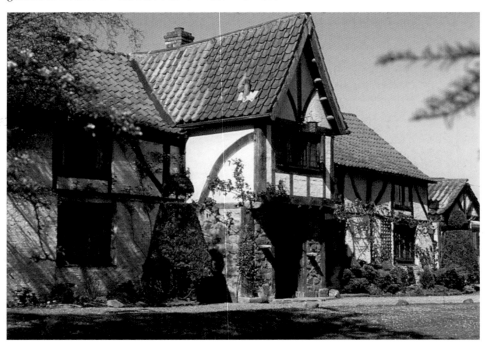

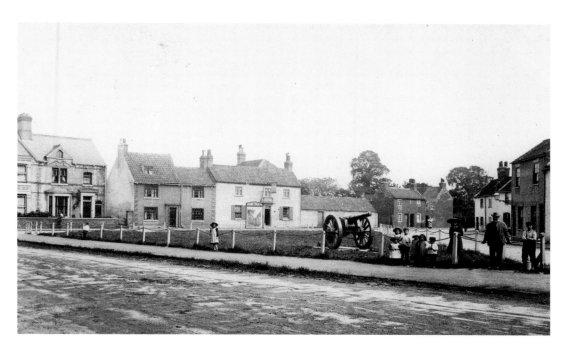

West Green, 1905

On the far side is the Blue Bell Inn (first licensed in 1823), displaying a large hoarding advertising Hull's Grand Theatre. Two Boer War cannons were acquired by Cottingham Council in 1904, one placed here at the west end of the village and one at the east end on Thwaite Street (see p. 96), 'guarding' the approaches to Cottingham. They removed this one in 1921 after it became 'a source of danger to the children'. Six lime trees were planted around 1911–12 to mark George V's Coronation; four survive.

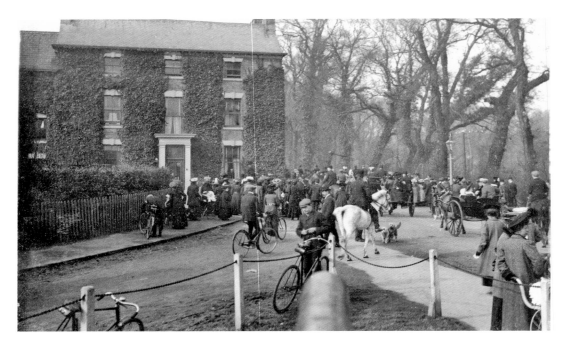

The New Year's Meet at Westfield House, *c.* 1905–07
Westfield House, a gentleman's country residence of around 1772, became a nightclub in the latter half of the twentieth century frequented by John Prescott, MP for Hull East. It is now the Fair Maid pub, named after Joan Plantagenet, the Fair Maid of Kent, who inherited Cottingham manor in 1352. Her second husband was Edward the Black Prince. The trees (right) border the outer castle rampart, round which Broad Lane Beck (inset) now flows through the front gardens of semi-detached houses built by Fred Whiting, 1932–34.

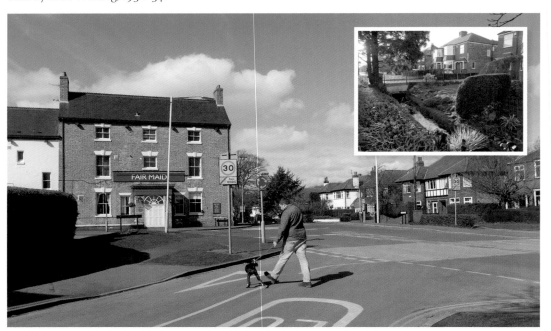

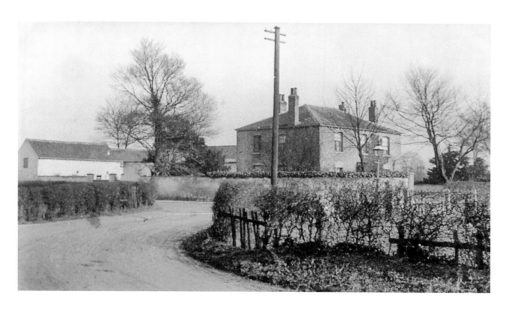

Southwood Villa, *c.* 1905

South Street, now a busy though-route to the hospital and A164, via Southwood Road and Castle Road, was once a quiet lane called Southgate or Back Street, a boundary between the village and the South Wood. Hull merchants erected houses here, including Southwood Villa, built before 1831 on the Baynard Avenue/South Street corner. It became home to the internationally renowned dress designer Madame Clapham, whose dressmaking salon opened in Hull in 1887. The lower photograph shows Cottingham's first council houses (left), built 1921/22, and a much widened Southwood Road.

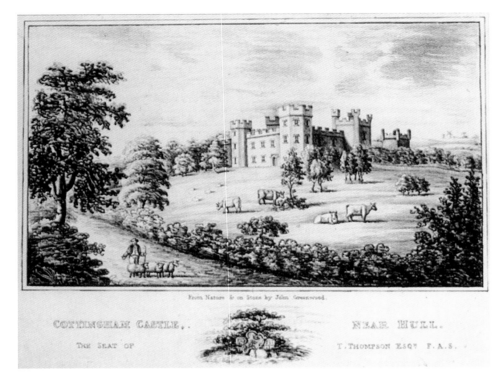

From Nature & on Stone by John Greenwood.

COTTINGHAM CASTLE,. NEAR HULL.

THE SEAT OF T.THOMPSON ESQ⁺ F.A.S.

Cottingham's Other 'Castle', *c. 1820/1930*

In 1800, Thomas Thompson, a philanthropic Hull banker, Methodist and friend of John Wesley and William Wilberforce, bought 54 acres of Cottingham's west field (enclosed in 1793), and built himself a castellated mansion in the Gothic style. 'Cottingham Castle' burned down in 1861, apart from a folly tower (still standing at the top of Castle Road) and a castellated gate further down Castle Road. The gate later formed the entrance to the TB sanatorium but was demolished in the late 1960s to make the entrance wider.

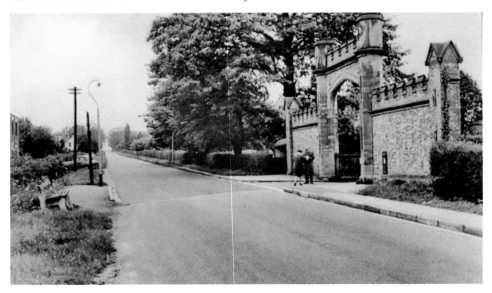

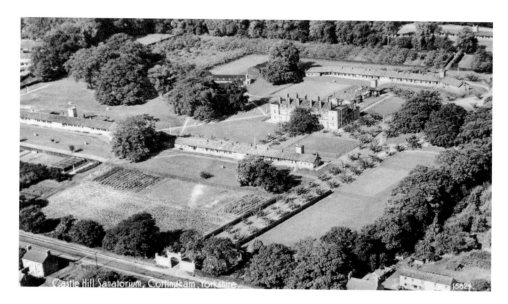

Castle Hill Sanatorium, Cottingham, Yorkshire. 15824

Castle Hill Hospital, Late 1930s/2011

In 1916, on the site of Thompson's burnt-out 'castle', Hull Corporation opened a TB sanatorium. The 1930s photograph, looking north-west, shows Castle Road, Cottingham Castle's gate and avenue (now entrance 3), the sanatorium farm (left), the staff accommodation and administration building (centre), and the rows of single-storey Infectious Diseases, TB and Smallpox wards. By 2011, looking eastward over Cottingham, the green and open land between Castle Road and Eppleworth Road had been developed into a major acute hospital, including regional centres for oncology and cardiology.

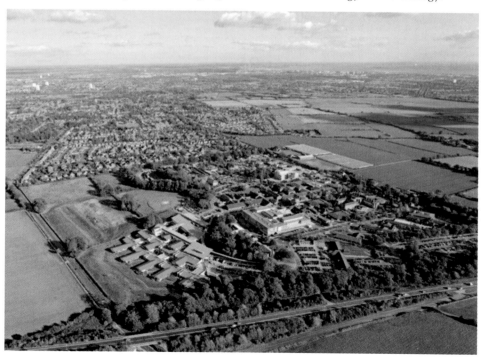

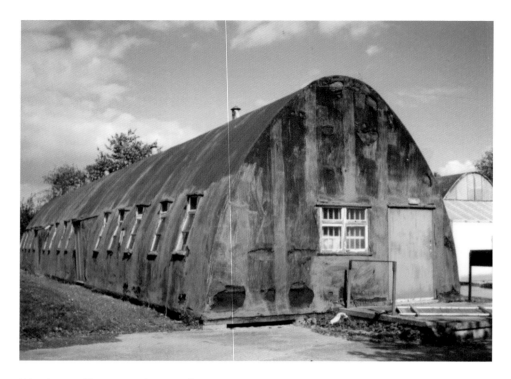

Wartime Utility to Modern Design

As part of the war effort in 1939, two Nissen huts were provided on the Castle Hill Hospital site with a total of sixty beds. They later became the Eastern Regional Smallpox Hospital. By 1988 they had been converted into Castle Hill Hospital's Upholstery Department and were subsequently demolished. The Queens Centre for Oncology and Haematology, shown here under construction (2007), was opened by the Queen in 2009. It provides 116 beds and many other cancer services for the region.

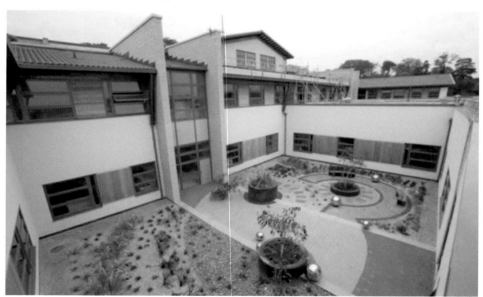

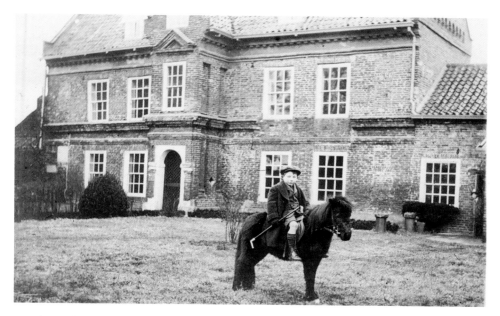

Southwood Hall, Burton Road, c. 1910/2004

In the sixteenth century, Cottingham's South Wood was owned by the Crown, then by the City of London. In the 1650s, John Bacchus, a Hull merchant, bought four closes and built Southwood Hall, 'an exceptional red brick and pantile house of *c.* 1660 with Artisan Mannerist details' (Pevsner & Neave, 1995). It may be the work of William Catlyn, who built Wilberforce House, High Street, Hull. Since 1999, the Barnes family have lovingly restored the Grade II* listed building, now surrounded by modern housing.

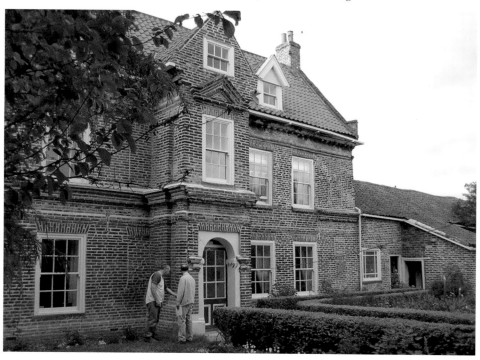

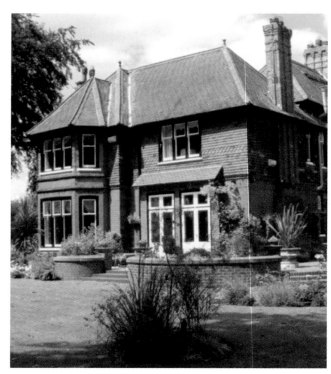

Bondyke House, 2006/c. 1930s
It was built in around 1882 on the corner of Southwood Road and St Margaret's Avenue, formerly called Bondyke Lane, First Green Lane or Merrikin's Lane. Designed by Smith and Brodrick, it is perhaps the only remaining example in Cottingham of the late nineteenth-century domestic revival style. Owners include: 1889–1940, the Merrikin family, Hull paint and varnish manufacturers; Harold ('Timber') Wood, chief test pilot at Brough, who made the first test flight of the Beverley transport aircraft; 1959–89, Bernard and Gladys Clifford, the King Street newsagent's; 1989 onwards, Kay and Tony Hailey OBE, the former CEO of the Swift Group, the major caravan manufacturer based in Cottingham.

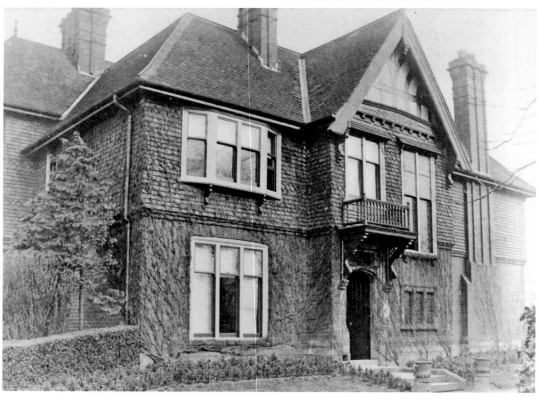

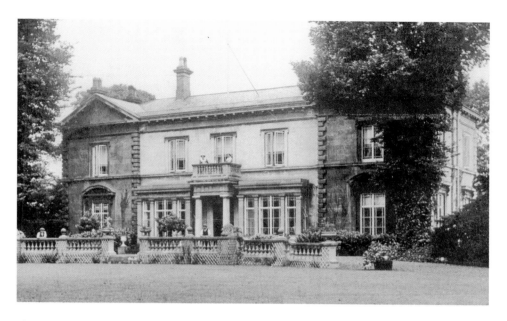

Elm Tree House, South Street, Early 1900s/2011

Built in the 1820s for John Hebblethwaite, a Hull draper, Elm Tree House was home to a succession of merchants, the last being coal exporter Gunther Lutze who, because of anti-German feelings in 1913–14, changed his surname to Lacey. From 1937 it was a university student residence, a wartime St John's First Aid post under GP Dr Halliwell and, since 1950, the Cottingham Memorial Club (entrance in Finkle Street). Its former front garden is now a public space ('Grandad's Park'), used on Cottingham Day for children's entertainments.

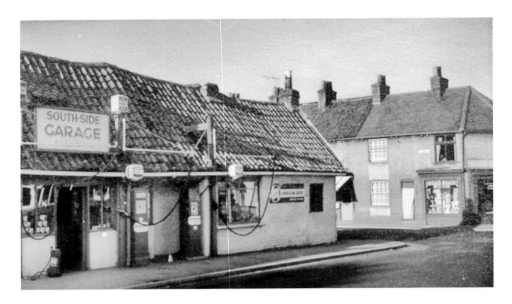

Ashton's Garage, South Street/King Street, *c.* 1935

These old cottages, possibly eighteenth century in origin, were converted by George Ashton shortly after 1900 for selling and repairing cycles and motorcycles. When motor cars became more common between the wars, he was the first to sell roadside petrol. The garage was demolished in 1978 when Elm Tree Court was built. Ashton had another pedal cycle shop on the opposite corner in the early 1900s but by 1935 it had become a general store. From the 1970s it was the Haltemprice Lions' charity shop but was demolished in a recent rebuilding of the corner.

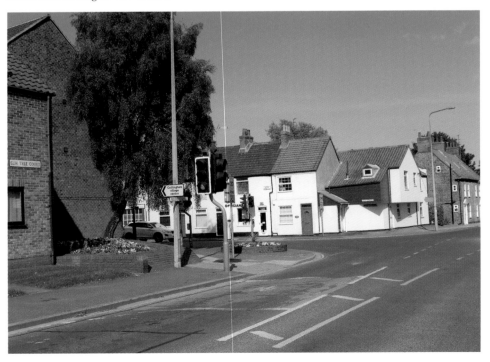

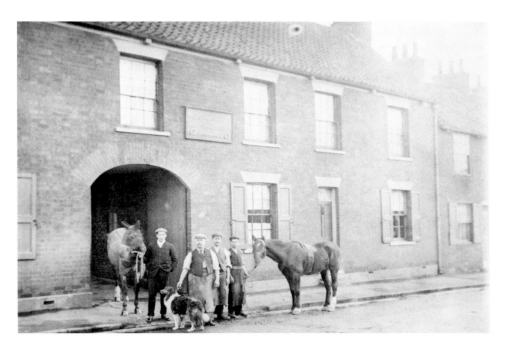

A King Street Blacksmith and Farrier

Before motorised transport and agricultural machines, people depended on horse power. Cottingham was full of horses and horse breeders, and farriers were much in demand. William Humble established his firm of blacksmiths and farriers in King Street in 1823, and the skill passed from father to son until Hubert Humble retired in 1956. Hubert's father William is shown here with his family in around 1905. Horse riding is still a popular leisure activity in Cottingham but the traffic and traffic lights of 2013 tell the rest of the story.

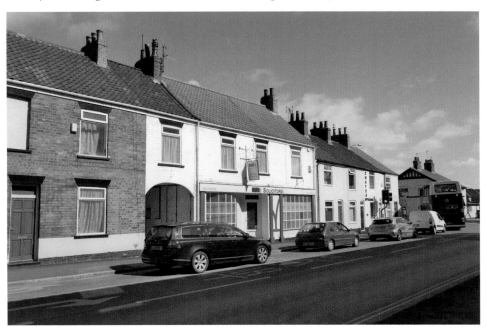

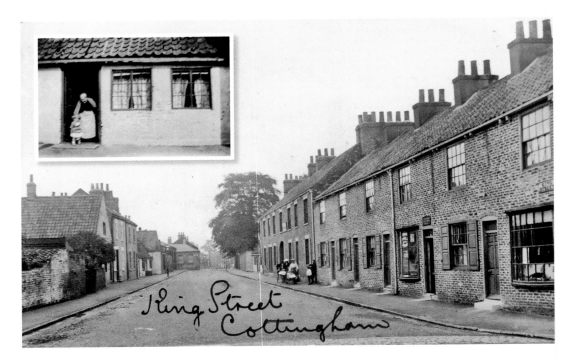

Grandma Akam's Cottage, *c. 1906*

At the end of the terraces (right) is a tiny white cottage where Granny Akam lived (seen at her front door, inset). She was one of the women who, before the NHS, attended and assisted with 'lying-in' (births) and 'laying-out' (deaths). Next door was Humble the blacksmith's, where a lasting relationship was forged (ahem!) between Violetta, her daughter, and blacksmith George Burrell. Granny Akam's son was George Akam, the lamplighter (p. 72). Elm Tree Court replaced the cottages and houses on the left in 1978.

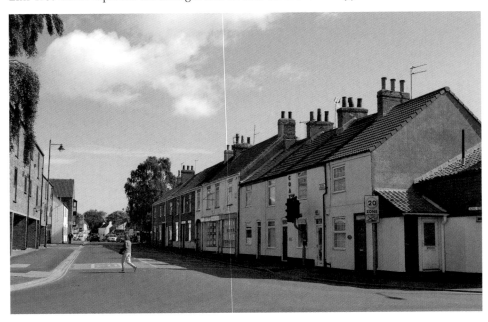

The King Street Rooms, 1975, and Elm Tree Court
For much of the twentieth century, the King Street Rooms, originally the National School (1836–93), were Cottingham's busiest social centre, used by St Mary's church, Second World War troops (as a canteen), the Darby and Joan Club (1950–55), guides and brownies, a dancing school and a nursery school (1960s). To their right, the flat-roofed post office and Moor Royal Court flats stand in the former gardens of Elm Tree House. The 'Rooms' were demolished in 1987 to build the apartments and shops of Elm Tree Court. The Millennium clock was donated by the parish council.

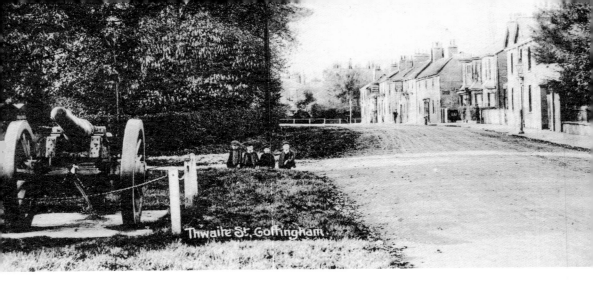

Thwaite St, Cottingham

Parting Shot: Thwaite Street, c. 1920
In 1904, Cottingham Council controversially acquired two decommissioned 40-pounder guns. This one, in a postcard by Herbert Beal, faced Hull, and the other at West Green faced Beverley (see p. 83). They originally evoked the glamour of victory in the Boer War and Cottingham's spirit of independence from its two larger neighbours. The guns and the glory of war-making have long gone but the determination to be independent remains.

Acknowledgements

The book was compiled by members of the Cottingham Local History Society: Peter McClure, Katrin McClure and Tony Grundy (editors), Dorothy Catterick, Rachel Waters, Tony and Kay Hailey, Shirley Patterson and James Hargreave. It has benefited especially from Dorothy Catterick's personal knowledge of the village and the postcard collections of Rachel Waters and Robert McMillan. Thanks are also due to Hull and East Yorkshire Hospitals NHS Trust, to hullandbarnsleyrailway.org.uk, and to the many people, too numerous to mention by name, who have contributed to the society's digital archive, from which most of the historic images in this book have been drawn. The archive was created with funding from the Local Heritage Initiative (2003–05). Undated photographs in the book were taken by the contributors in 2013. The most used sources of information were: the Society's own booklets; articles in the Society's journal; *Cottingham in the 20th Century* (ed. J. Markham, 2005); K. J. Allison, 'Cottingham', in *York East Riding*, IV (Victoria County History, 1979), *Hull Gent Seeks Country Residence, 1750–1850* (1981), and *Cottingham Houses* (2001); K. R. and E. M. Green, *Cottingham in Old Picture Postcards* (2nd ed., 1988); Kenneth R. Green, *Old Cottingham Remembered* (1988); N. Pevsner, D. Neave, S. Neave and J. Hutchinson, *Yorkshire: York and the East Riding* (1995); A. H. Stamp, *Cottingham Essays* (1986) (ed.), *Memories of Cottingham* (1990) (ed.), *Further Memories of Cottingham* (1991), and *Last of the Cottingham Essays* (1993); Rachel Waters, 'Cottingham Postcard Publishers', *The East Yorkshire Historian*, 6 (2005), 106–16, and *Then and Now Cottingham* (2007).